DIRECTOR'S CHOICE
HUGH LANE
GALLERY

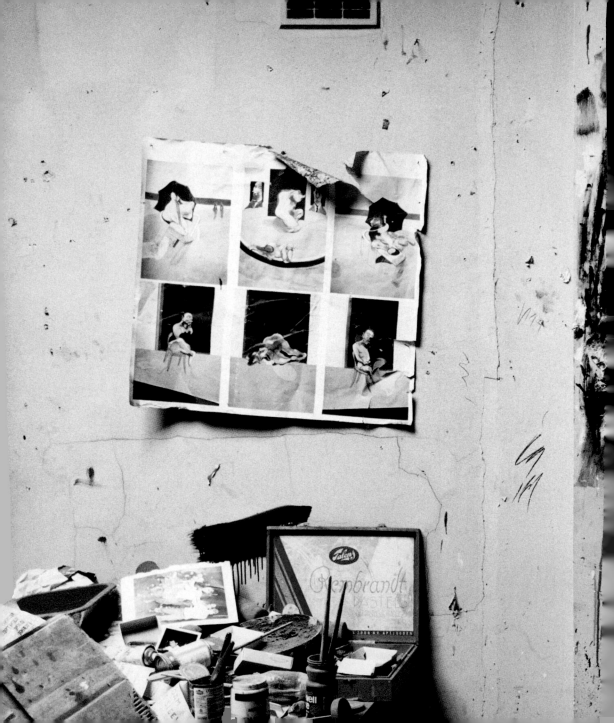

HUGH LANE GALLERY

Barbara Dawson

Comhairle Cathrach
Bhaile Átha Cliath
Dublin City Council

SCALA

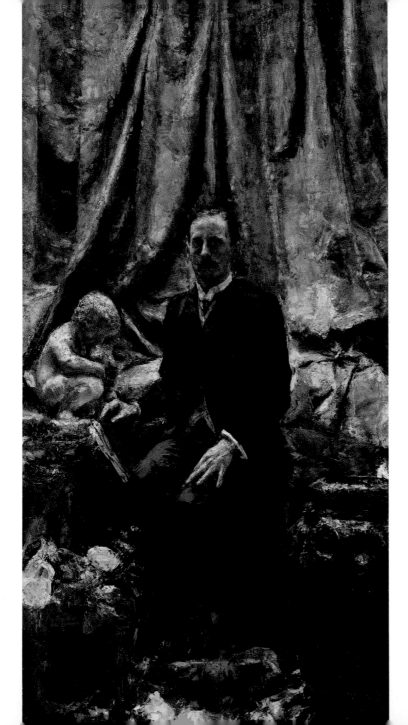

ANTONIO MANCINI (1852–1930)
Portrait of Hugh Lane
Oil on canvas, 226.1 x 116.8 cm
Signed and dated, lower right:
A. Mancini / Roma 1907
Lane Bequest, 1913
Reg. 148

INTRODUCTION

Hugh Lane's interest in Irish art was ignited by an exhibition of paintings by Nathaniel Hone and John Butler Yeats organised by artist Sarah Purser in 1901. A successful art dealer based in London, Lane was determined to establish a gallery of modern art to complement the Irish Literary Revival. In 1904, he organised the first ever exhibition of Irish art in London's Guildhall. Later that year he organised the first exhibition of Impressionist art in Ireland or Britain, with paintings lent by the Parisian dealer Paul Durand-Ruel, several of which Lane purchased for the gallery. The gallery opened in 1908 as the Municipal Gallery of Modern Art. It was one of the most significant cultural events in the birth of Modern Ireland.

Due to the controversy that arose over constructing a dedicated gallery for the collection, in 1913 Lane selected thirty-nine paintings to lend to the National Gallery, London, for a special display. However, the display never materialised, and the paintings remained in storage. In February 1915, before sailing to New York, and disillusioned with London, Lane wrote a codicil to his will of 1913, bequeathing instead these artworks to Dublin, but he failed to have it witnessed. Sir Hugh Lane died aboard the Lusitania when it was torpedoed on 7 May 1915 off the coast of Cork. His unwitnessed codicil was found to be illegal under English Law despite it being war time and, despite his wishes, the National Gallery London claimed ownership. Following decades of controversy, in 1959, the first agreement to share the pictures was reached. In 2021, a new partnership agreement strengthening the relationship between the two galleries was concluded. The gallery continues to acquire for the collection in the spirit of Hugh Lane, who declared, 'for it's one's contemporaries that teach one the most'.

ÉDOUARD MANET
(1832–1883)

Eva Gonzalès, 1870

Oil on canvas, 191.1 x 133.4 cm

Signed and dated, lower right: Manet 1870

Sir Hugh Lane Bequest, 1917, National Gallery, London. In partnership with Hugh Lane Gallery, Dublin

Reg. 3259

RIDICULED AND REJECTED by the art establishment throughout his life, Édouard Manet nonetheless was acclaimed as the father of Modern art, celebrated for his pioneering imagery of contemporary life in France. In 1869, Eva Gonzalès became Manet's one and only pupil. This monumental portrait presents Gonzalès centre stage with a directness and clarity for which the artist became renowned. Manet places the artist seated in the process of painting a still life. He directs the viewer's gaze upwards, suggesting a particular esteem for his pupil. Gonzalès's statuesque beauty is complemented by her simple, elegant gown, painted in Manet's signature luminous white.

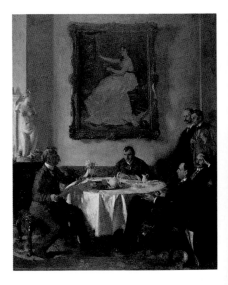

Eva Gonzalès and *An Itinerant Musician* were the first two paintings by Manet shown in Dublin as part of Lane's exhibition in the RHA in November 1904. In his memoirs, the writer and dramatist George Moore recounts how, when attending this exhibition, Lane asked him which of two paintings he should buy. Moore (one of the few Irish people well acquainted with Manet and the Impressionist painters), who had his portrait painted twice by Manet, replied that no matter which Lane chose he would regret not having selected the other. Lane chose Eva, and purchased it the following year, arousing great excitement amongst his friends and supporters, with Moore declaring, 'Ireland would be better served to gaze upon the raised arm on Mlle Gonzales than on the meagre thighs of martyred saints.'

In celebration of the acquisition of *Eva Gonzalès*, William Orpen painted *Homage to Manet* (1909), which shows Lane seated with his head resting in his hand.

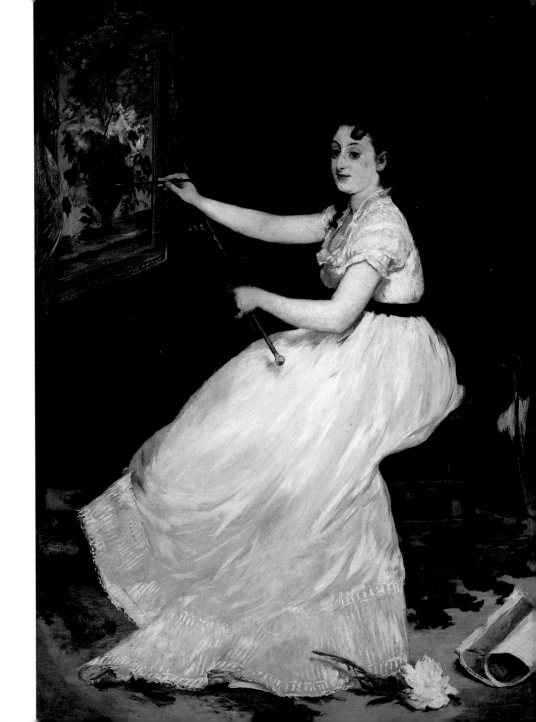

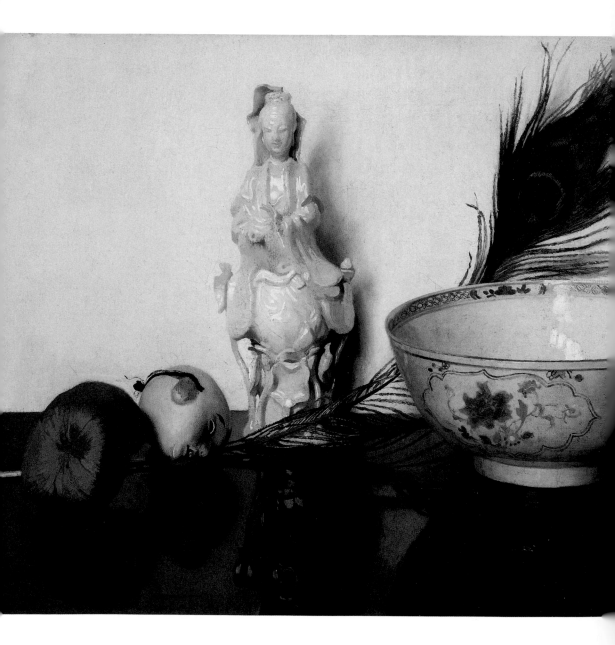

SIR WILLIAM ORPEN
(1878–1931)

Reflections: China and Japan, 1902
Oil on canvas, 40.5 x 51 cm
Lane Gift, 1912
Reg. 35

WILLIAM ORPEN, WHOSE PRACTICE was based in London, was one of the most successful painters of his generation. An influential and important figure in Irish art and a part-time teacher at the Dublin Metropolitan School of Art, he exercised great influence on the next generation of Irish artists. He was a friend and advisor to Hugh Lane, and introduced him to the Parisian art dealer Paul Durand-Ruel, from whom Lane bought several of his Impressionist paintings. Orpen celebrated Lane's acquisition of *Eve Gonzalès* by Manet with a huge group portrait, *Homage to Manet*, 1909 (see p.6), featuring George Moore, Wilson Steer, D.S. McColl, Walter Sickert, Hugh Lane and Henry Tonks, overlooked by the magnificent *Gonzalès*. Like Manet, Orpen greatly admired Velázquez, and his oeuvre shows his preference for form and structure over colour.

Reflections: China and Japan was painted when Orpen was just 24, and reveals extraordinary skill and delicacy in the handling of his subject matter. The even light sees the objects reflected on the highly polished surface, giving the painting added depth. It is a curious composition. The peacock feather, a symbol of nobility, compassion and goodwill, is associated with both Japanese and Chinese culture. The jade figure appears to be Kannon, the deity associated with the peacock in Japanese culture, while the Chinese Famille Rose bowl is delicately adorned in the centre by a red peony, the Chinese symbol of royalty and virtue. The china doll in the foreground, knocked over in a similarly defeated position to checkmate in chess, adds to the enigma.

PIERRE-AUGUSTE RENOIR
(1841–1919)

Les Parapluies, *c.*1878–85/6

Oil on canvas, 180.3 x 114.9 cm

Signed, lower right: Renoir

Sir Hugh Lane Bequest, 1917, National Gallery, London. In partnership with Hugh Lane Gallery, Dublin

Reg. 3268

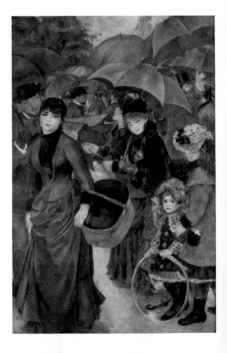

IN A LETTER TO HUGH LANE DATED 13 November 1907, the Parisian dealers Durand-Ruel state that Renoir painted this iconic work in his studio in Rue Ravignan, Paris, between 1878 and 1885/6, and that it was one of the paintings that gave him the most trouble and pain. Lane bought it as a birthday present to himself. He subsequently made it part of the public collection for the Municipal Gallery of Modern Art Dublin, established in 1908.

This painting came about in stages over its eight years of creation, and through it we can trace Renoir's development away from his Impressionist style of bright palette and loose deft brushwork to the more sculpted, classical compositions he favoured for a period in the 1880s.

This is a wonderful scene of everyday life in Paris. The jostling crowd holding umbrellas in various stages of opening are stacked against each other along the street, which, with the tall buildings to the upper right suggesting a steep incline, could be Rue Ravignan.

The figures on the right are built up in soft brushwork with a vivid cobalt blue palette offset by coral flesh and hair tones. The later figures to the left in contrast are more sculpted, with a muted palette of ultramarine. The young woman's streamlined figure in a tight bodice is in keeping with the fashion for modistes of the mid- to late 1880s. An undertone of sexual tension is created by the young man's lingering gaze at the beautiful model, who wears an air of gentle resignation.

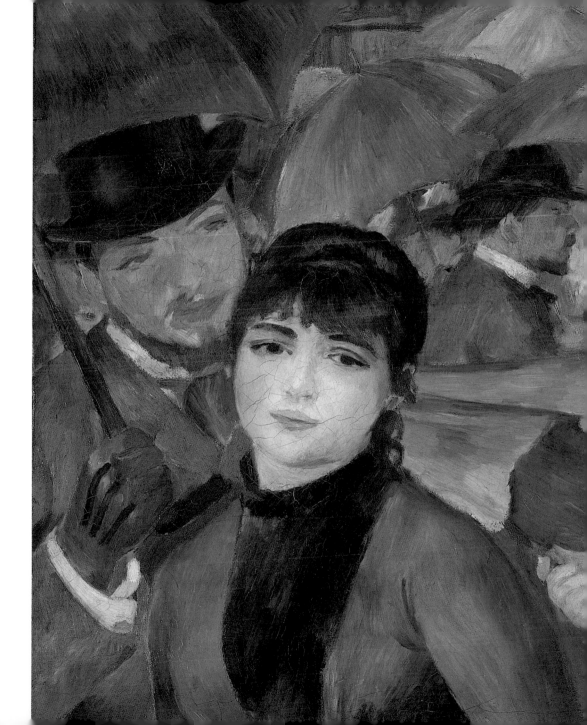

BERTHE MORISOT
(1841–1895)

Jour d'Été, *c.*1879

Oil on canvas, 45.7 x 75.2 cm

Signed, lower right: Berthe Morisot

Sir Hugh Lane Bequest, 1917, National Gallery, London. In partnership with Hugh Lane Gallery, Dublin

Reg. 3264

THIS IS ONE OF THE LAST Impressionist paintings that Sir Hugh Lane purchased for his modern collection. He acquired it from the Durand-Ruel Gallery, Paris, in 1912. First exhibited in the Impressionist Exhibition of 1880, Berthe Morisot was by then an established member of the group, and the only woman who had exhibited in all but one of the eight Impressionist Exhibitions held between 1874 and 1886.

Jour d'Été shows two well-dressed ladies boating on Lac Inférieur in the Bois de Boulogne in Paris. It reveals Morisot's style of Impressionist painting: confident, deft brushwork that dissolves solid form into a luminous composition of brilliant colours. Her subject matter, drawn from her experiences of middle-class Parisian life, is imbued with a subtlety and depth of feeling that was at one time dismissed by critics as trivial. But her revolutionary approach to painting ranks her amongst the great painters of the late nineteenth century, and her subject matter, treated with a nuanced intimacy, makes for compelling viewing.

As well as being artistically acclaimed, this painting was at the centre of a cause célèbre in 1956, when two Irish students, Paul Hogan and Bill Fogarty, removed the work from the Tate Gallery, London, in a bid to highlight the controversy surrounding Sir Hugh Lane's bequest of 39 paintings that were held by the National Gallery, London, (see p.5). This publicity stunt caused uproar and embarrassment in both Dublin and London, but it did lead to the first agreement to share the paintings with Dublin.

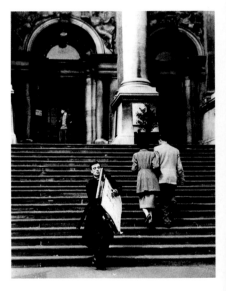

Paul Hogan with the Morisot painting and Bill Fogarty standing at the top of the steps.

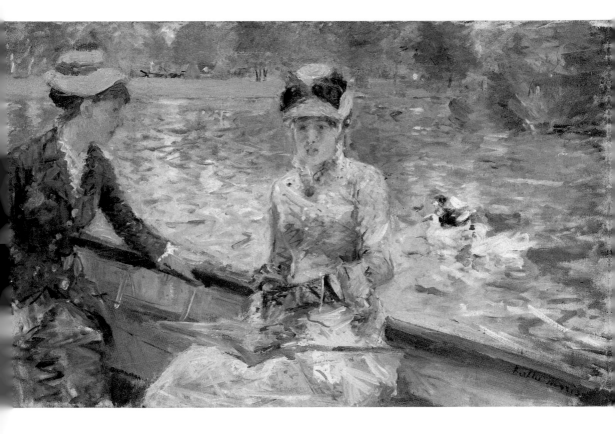

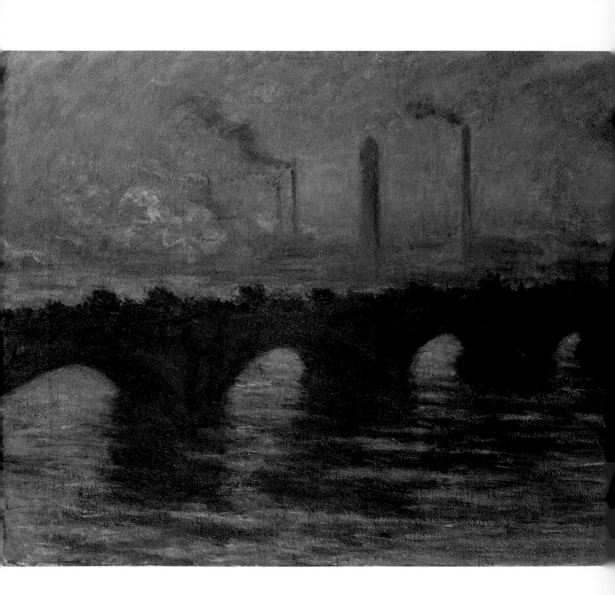

CLAUDE MONET
(1840–1927)

Waterloo Bridge, overcast weather, 1900
Oil on canvas, 65 x 100 cm
Signed and dated, lower right: Claude Monet, 1900
Donated by Mrs Ella Fry, 1905
Reg. 304

MONET MUST HAVE BEEN one of the few people who loved London's industrial fog, saying the city would not have been so beautiful without it. As well as being a heavy pollutant, it diffused the light over the city, creating a misty, moody atmosphere. In his series of 41 paintings of Waterloo Bridge created between 1899 and 1901, Monet captured the effects of the fog on the stone bridge to stunning effect.

Monet painted his *Waterloo Bridge* series from his suite on the fifth floor of the Savoy Hotel. This painting shows the busy bridge on an overcast day. The pink light in the distance spreads a warm glow across the murky grey sky, casting a purplish hue over the industrial chimney stacks belching out their fumes. The morning sky spreads a hazy warmth over the cold water of the River Thames flowing through the arched bridge, while above the traffic jostles across this important thoroughfare. Monet's work is quintessential Impressionist painting, concentrating on the effects of light and colour on objects, effectively dissolving the form into an overall atmospheric scene.

This was one of a number of Impressionist paintings lent by the Parisian art dealer Paul Durand-Ruel to Hugh Lane for his exhibition in Dublin in 1904. The painting was subsequently included in Paul Durand-Ruel's Impressionist exhibition in the Grafton Galleries, London, the following year. Lane haggled over the price, offering the dealer £200, which he declined.

This painting was purchased by Mrs Ella Fry for £600 and donated to the gallery. As she explained it, this was not because she loved Dublin – she had never been – but because she fully supported the vision of Hugh Lane to create a gallery of modern art.

ANTONIO MANCINI
(1852–1930)

Lady Gregory, 1907

Oil on panel, 74 x 57 cm
Signed and dated, lower left: A. Mancini / Dublin / 1907
Lane Gift, 1912
Reg. 44

IN A LETTER TO JOHN SINGER SARGENT in December 1904, Antonio Mancini, the Neapolitan artist, excitedly discusses his commission from Hugh Lane for three paintings. One was for a portrait of Hugh Lane; the other two were for Lane's sister, Augusta Ruth Lane, and his aunt, Augusta Lady Gregory. In her biography of Hugh Lane, Lady Gregory, co-founder of the Abbey Theatre, describes Mancini's bizarre working methods as she sat for her portrait.

Placed on a high chair, Mancini set up a frame in front of her to which he pinned many threads crossing one another. He set up a similar frame in front of his canvas. Standing far back, he would then approach, breaking into a quick trot, with his brush aimed at some feature on her face, when, at the last minute, he would swerve to the canvas and plant a brushstroke. It took a courageous sitter not to move!

In W.B. Yeats's poem 'The Municipal Gallery Revisited' he describes Lady Gregory's portrait thus: 'Mancini's portrait of Augusta Gregory / "Greatest since Rembrandt," according to John Synge'.

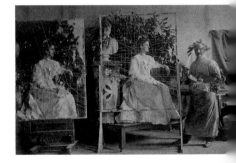

Ruth Shine (*née* Lane), Hugh Lane's sister, sitting for her portrait by Mancini. He is seen painting while adorned by a wreath of laurels.

Gregory is seated looking directly at the viewer. In her left hand, which is adorned with bracelets and rings, she holds one of her two famous ostrich fans which she filled with autographs of celebrities, Mancini included. The sensitive modelling of light and shade against the dark background illuminates the sitter, revealing both her femininity and her strength of character. Mancini is not a rival of Rembrandt, but in this portrait he has given us an astute and discerning insight into the personality of one of the most significant figures in twentieth-century Irish history.

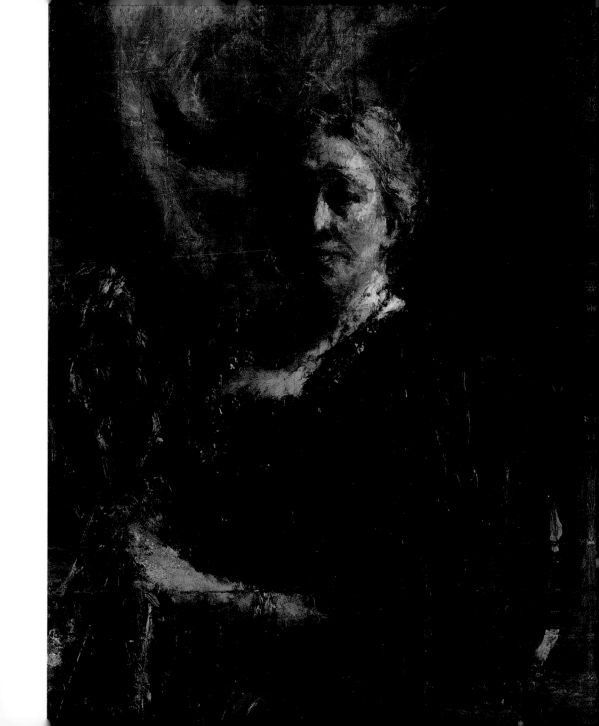

John Butler Yeats
(1839–1922)

William Butler Yeats, *c.*1886

Oil on canvas, 76.6 x 64 cm
Lane Gift, 1912
Reg. 55

John Butler Yeats (JBY) completed this portrait of his son William Butler Yeats (WBY) in *c.*1886, when the poet was emerging as a literary figure of consequence. It is a sensitive and affectionate portrayal of the young poet. WBY avoids the gaze of the viewer. Head down, he concentrates on his reading, suggesting a rather shy and thoughtful demeanour. Aware of his son's genius, JBY confessed (as quoted in Roy Foster's biography of WBY), 'I watched him as the mousing cat, fearful lest some inclination which I had deplored in my family or in his mother's might develop to his undoing.'

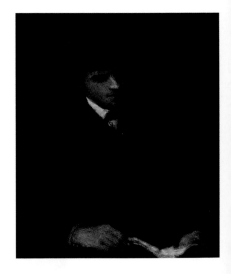

A brilliant conversationalist, JBY began his career as a barrister in Dublin. He married Susan Pollexfen from Sligo. The magnificent scenery of that county went on to become a significant inspiration for WBY's poetry and his brother Jack's paintings. JBY left the bar soon after his marriage to become an artist. He received critical success for the sketch-like spontaneity and verve he achieved in his portraits. In 1901 the artist Sarah Purser, in protest at the reactionary RHA, organised an independent joint exhibition of his work with that of Nathaniel Hone. Purser brought Hugh Lane to see the exhibition and, on foot of that, Lane commissioned JBY to paint portraits of several notable Irish personalities. JBY was delighted with the advance of money, however he eventually abandoned the commission and in 1907 moved to New York, where he was taken under the wing of the Irish American lawyer John Quinn, an avid patron of the arts. Quinn commissioned JBY to paint a self-portrait, which would become an obsession for the artist for the rest of his life.

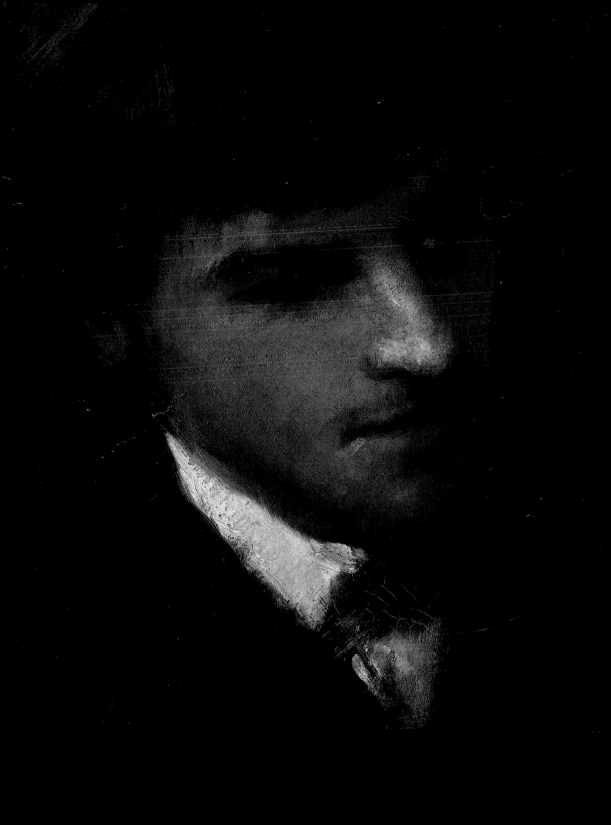

Frank Joseph O'Meara
(1853–1888)

Towards Night and Winter, 1885

Oil on canvas, 150 x 125 cm
Signed and dated, lower left: Frank O'Meara 1885
Lane Gift, 1912
Reg. 26

At Grez-sur-Loing you will meet 'the irresistible Frank O'Meara' – so wrote John Singer Sargent in the summer of 1875. Grez-sur-Loing was a pretty village on the edge of the Forest of Fontainebleau, which O'Meara, Sargent and fellow students from Carolus-Duran's studio discovered in the summer of 1875. Its medieval architecture and narrow cobbled streets provided a picturesque backdrop to the River Loing that flows through the village, and the old stone bridge with its many arches features in several of the artists' paintings.

Frank O'Meara stayed for thirteen years in Grez. He was considered the genius loci, and influenced many of the visiting artists includ-ing John Lavery, whose painting *Under the Cherry Tree* is similar in style and subject matter to *Towards Night and Winter*. O'Meara favoured autumnal scenes in his paintings, capturing the cool grey light and the rich russets, browns and greens of the Grez landscape at that time of year. *Towards Night and Winter*, with its lone figure in reverie standing on the banks of the river burning leaves, creates an ethereal, enigmatic atmosphere that is characteristic of O'Meara's work.

The young woman is Mary Isabelle 'Belle' Bowes, the artist's fiancée and muse, whom he met in 1880. Dressed in the pale-grey linen costume of the villagers, she strikes a graceful pose, holding dead leaves in her apron. Her dreamy expression as she carries out her task, bathed in the beautiful, clear light, reveals the artist's tenderness for his subject. Suffering from malaria, Frank was never to marry Belle; he died in his native Carlow aged 35.

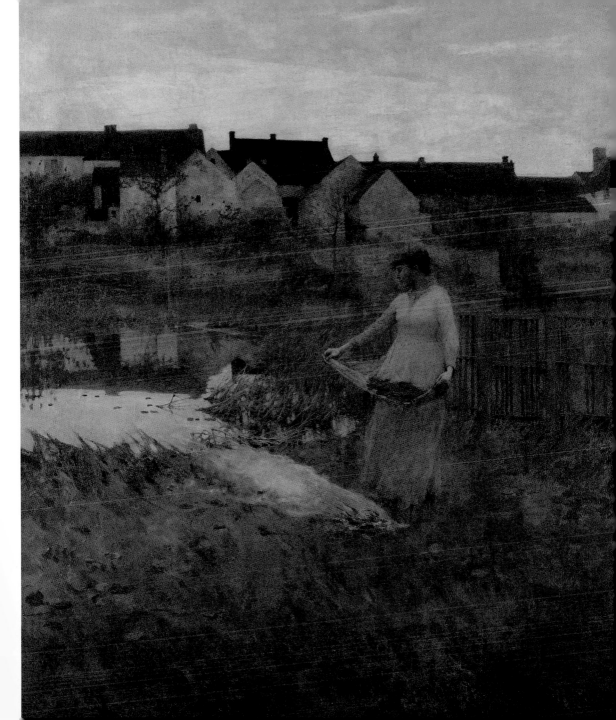

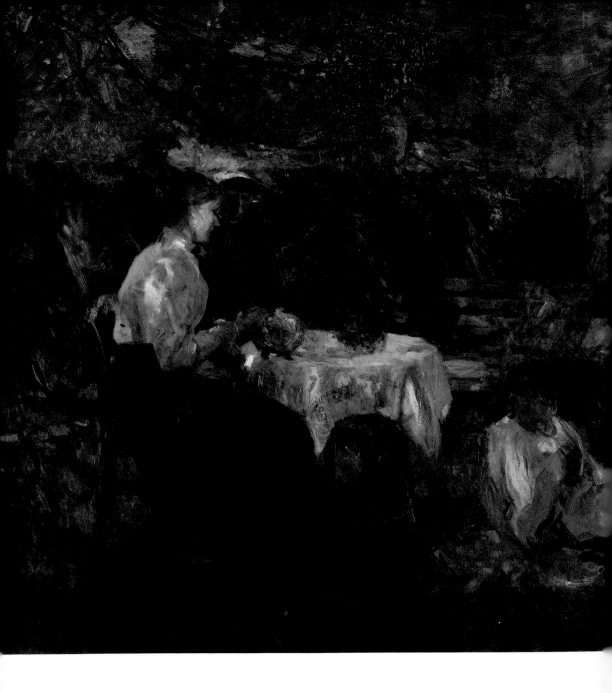

WALTER FREDERICK OSBORNE
(1859–1903)

Tea in the Garden, 1902

Oil on canvas, 132 x 217 cm
Lane Gift, 1912
Reg. 24

TEA IN THE GARDEN WAS BOUGHT BY HUGH LANE at Walter Osborne's retrospective at the RHA in the winter of 1903. Shocked by his unexpected death, and regarding him as one of Ireland's most distinguished painters, Lane was anxious to secure some of his key paintings for the gallery.

In 1881 and 1882, Osborne won the Taylor Art Award, which enabled him to study abroad. He followed a path favoured by Irish artists at the end of the nineteenth century, first studying in Antwerp and then on to Brittany to the artists' colonies of Pont-Aven, Dinan and Quimperlé, where he adopted the *en plein air* style of painting. He was a regular exhibitor with the New English Art Club as well as with the RHA.

In the early 1890s, an Impressionist influence began to appear in his work. His later palette became more colourful and his brushwork looser, revealing an increased interest in the effects of sunlight and shade. *Tea in the Garden* is one of Osborne's finest late works. It portrays his neighbours, the Crawfords, in Castlewood Avenue, Rathmines, Dublin.

The garden composition is built up in blocks of colour with deft, delicate brushwork. Dappled sunshine flits upon the surfaces, highlighting the Lustreware teapot with its metallic glaze. Overhead the branches of the lime trees cast dancing shadows across the scene, and to the right an elderly female figure emerges from a loosely sketched background. The painting remained unfinished at the time of his death. In 1900 Osborne was offered a knighthood, which he declined due to his concern at the financial pressures it would entail. Three years later he died of pneumonia aged 43.

GRACE HENRY
(1868–1953)

Evening, Achill, 1912–19

Oil on canvas, 58.5 x 49.5 cm

Signed, lower right: Grace Henry

Purchased, 1995

Reg. 1885

GRACE HENRY'S WORK IS SLOWLY receiving the appreciation it deserves. Born in Scotland, where she exhibited with the Aberdeen Artists' Society in 1896 and 1898, she moved in 1900 to Paris, where she came under the influence of Whistler, at whose Académie Carmen her future husband, Paul Henry, worked for a time. She developed an individual and pioneering style of landscape painting, comprising strongly delineated simplified forms and modulated colour.

Achill Island, on the western seaboard of Ireland, is noted for its wild landscape and traditional culture, and has attracted artists and writers over the centuries. Grace Henry lived there with her husband from 1910 to 1911 and then from 1912 to 1919. She subsequently travelled extensively in France and Italy, but it was on Achill that she developed her unique responses to landscape painting and where she created some of her finest work.

During her time on Achill, Henry very much favoured nocturnal scenes, and long after leaving the island she was remembered for her tendency to set up her easel out of doors under a moonlit sky. In *Evening, Achill* a sense of drama prevails. The landscape is dominated by a surreal Prussian-blue sky underlaid with black. The focus is on one bright star which illuminates the whole expanse, picking out the contours of the cliffs behind the little curved thatched cottages lit from within which fade into the landscape. There is great delicacy in her handling of paint, which she goes on to develop into more textured compositions in her later work. This marvellous modernist response to the rugged terrain of Achill is amongst the most expressive landscapes of the period.

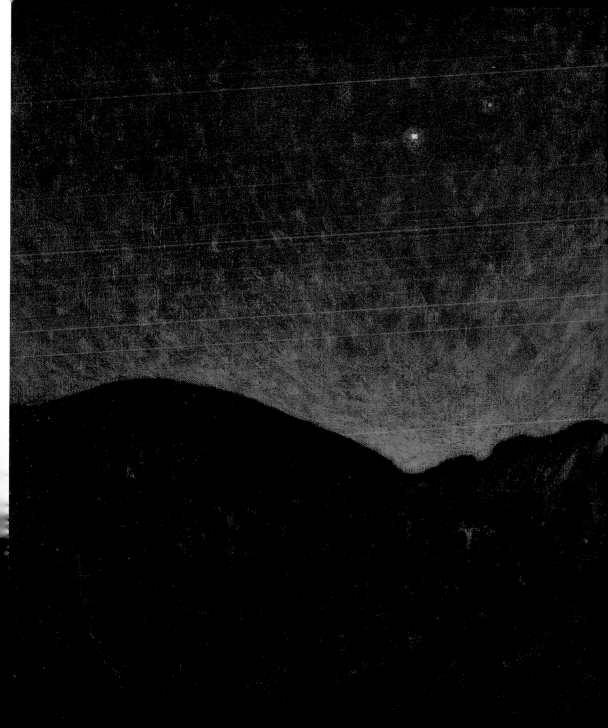

FRANÇOIS-AUGUSTE-RENÉ RODIN
(1840–1917)

George Bernard Shaw, 1906

Marble, 59 × 47.5 x 28 cm

Inscribed, on base, verso left: A. Rodin

Donated by George Bernard Shaw, 1908

Reg. 534

THE IRISH PLAYWRIGHT GEORGE BERNARD SHAW was a towering figure in English literature. He was awarded the Nobel Prize in 1925, two years after his fellow Irishman W.B. Yeats. A polemical figure in politics and on social issues, he denounced both sides in the First World War and, although not a nationalist, was fiercely critical of British policy in Ireland.

He involved himself in the appeal by Roger Casement (see p.29) of his sentence to death on the charge of treason. Although Shaw did not agree with Casement's politics, in his opinion, as an Irishman, Casement owed no allegiance to the British Crown, and he had the right to do what he thought was best for his country. In typical Shavian manner, Shaw attempted to persuade Casement to stage a dramatic performance based on this argument, which would win over the jury and save his life. Casement failed to be swayed.

Shaw's wife Charlotte commissioned this marble bust as well as a bronze cast from Auguste Rodin. Shaw sat for the artist in April 1906 in Meudon. Rodin's assistant, Ren Chruy, recounted how Rodin interrupted his work, declaring, 'Do you know, you look like – like the devil', to which Shaw replied with a smile, 'But I am the devil!'

Shaw remarked that while the bronze is very much him, the marble is completely different – 'it does not have the aspect of a solid'. Rodin's marble sculpture is all luminosity and éclat, a unique portrait of this brilliant, controversial figure.

In support of Hugh Lane, Shaw donated the bust to the gallery in 1908.

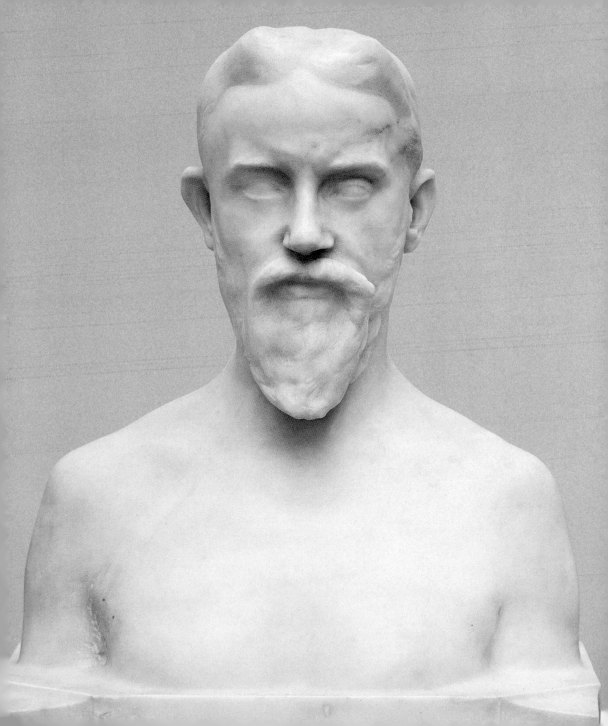

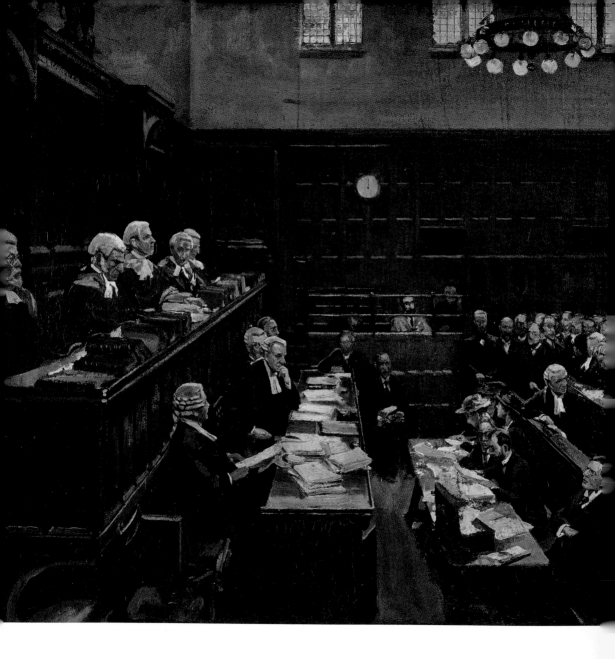

Sir John Lavery
(1856–1941)

The Court of Criminal Appeal. London. 1916. (Roger Casement), 1916

Oil on panel, 80 x 63.5 cm

Signed, lower right: J Lavery

Lady Lavery Memorial Bequest through Sir John Lavery, 1935

Reg. 753

'MUCH ASTONISHMENT HAS BEEN CAUSED in artistic circles … that Mr John Lavery is engaged in painting the final scene in the Casement trial … Mr Lavery ought not to paint his picture without knowing the contents of the two diaries … it is scarcely the kind of notice so popular an artist is seeking' – so reported *The Weekly Dispatch* in 1916. Roger Casement sought to overturn his sentence of death for treason in London's Court of Appeal, for attempting to bring arms from Germany to Ireland in support of the 1916 Rising. A former diplomat in the British Civil Service, Casement was knighted for his great humanitarian work in Africa and South America. His reports halted King Leopold's atrocities on the Congolese, as well as rubber barons' appalling attacks on the people of Putumayo in Brazil. The attempt to bring arms to Ireland failed; Casement was arrested and his character was well and truly destroyed by the British establishment, who publicly circulated his private diaries known as the 'Black Diaries', which recount a very active homosexual life.

The Belfast-born artist John Lavery enjoyed great popularity as a portrait painter in London, and numbered among his patrons members of the aristocracy and the political establishment. Taking on such a contentious subject was a gamble, but he went ahead nevertheless. He creates a dramatic scene that is cinematic in its composition and perfectly nuanced. The judges in their scarlet robes sit aloft on the bench, looking down on a diminutive Casement placed centre stage behind bars, a Christlike figure awaiting death. Lavery's career did not suffer. He was knighted in 1918, and continued his involvement in Irish politics.

ALAN PHELAN
(b.1968)

Our Kind, 2016
DVD, 30-minute HD film
Purchased, 2016
Reg. 2058

OUR KIND, A FILM BY ALAN PHELAN, is a counterfactual response to the tragic demise of Roger Casement, who was hanged for treason by the British government in 1916. *Our Kind* imagines what the future would have held for Casement had he not been executed. Casement's life and career was the stuff of a nineteenth-century adventure novel. Working first for the merchant navies, and then the British Foreign Service in Africa and South America, Casement successfully halted some of the worst human atrocities in colonial history before taking up the cause for Irish nationalism. The final twist in the adventure was the discovery of his 'Black Diaries', which relayed his active homosexual life and ensured his execution. Fact or fiction, Casement never confirmed, and the resulting scholarship for decades was muddied by homophobia and political prejudices.

In *Our Kind*, which is set in 1941, Casement has moved to Norway with his manservant and lover, Eivind Adler Christensen, who was also probably a British spy. Alice Stopford Green, an old friend and supporter of Casement, makes a visit. Interwoven with historical facts, the film creates a climate of controversy and intrigue similar to that which surrounded Casement's life. Presenting himself as a wronged man, Casement nonetheless does not fully explain his circumstances. Stopford Green's sexual encounter with Christensen, and Christensen's taunting of his lover, further exacerbates this sense of betrayal and resignation. Set against the rise of Nazism, this intriguing film is a masterly commentary on the complexities inherent in historical personae which deny any single reading.

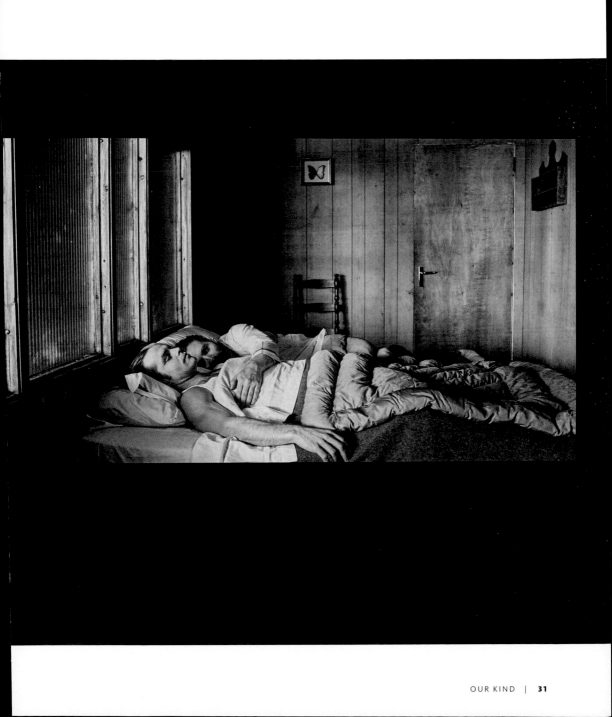

Mary Swanzy
(1882–1978)

Honolulu Garden, 1923–4

Oil on canvas, 62.9 x 75.4 cm
Signed, lower left: SWANZY
Purchased, 1976
Reg. 1491

Mary Swanzy was a remarkably intrepid woman whose travels to the Pacific Islands in the 1920s reveal her courageous and indomitable personality, as well as her fearless commitment to her art practice. She is believed to have been the first Western woman artist to travel to Samoa, and to exhibit the results of her experiences.

Born in Dublin, she travelled in 1904 to Paris, where she soon immersed herself in the avant-garde milieu and the emerging Cubist movement. For a time, she studied under Antonio de La Gándara, a noted society painter, and it was probably through him that she was introduced to Gertrude Stein, one of the great patrons of modern art in Paris. It was at her apartment that Swanzy gained great insight into modern art and the ensuing discourse, as there she saw first-hand works by Picasso, Cézanne, Braque and Matisse – artists with whom she became well-acquainted. Swanzy embraced these pioneering developments, and her signature style, a colourful and lyrical version of Cubism, emerged.

In 1923 Swanzy set sail for Hawaii and Samoa. Her uncle, Francis Swanzy, had emigrated to Honolulu in 1880, becoming a successful sugar baron. After he died his widow Julia invited her to visit. Swanzy delighted in the exotic, luxuriant plant life, tropical light and abundance of colour that greeted her in the Pacific Islands. She was 'stunned by how many greens there are in the world'. Her work reflects the excitement she felt upon encountering these unfamiliar scenes and people. Her simplified flattened shapes imbued with the exotic colouring capture the drama of these flamboyant landscapes.

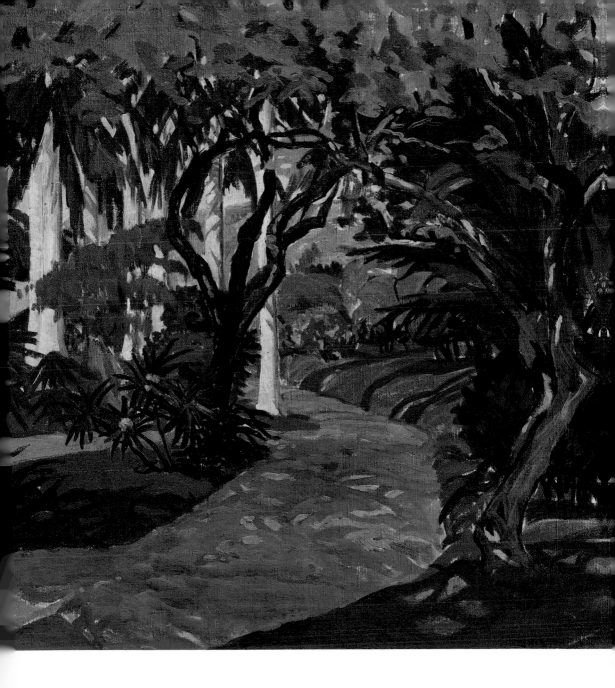

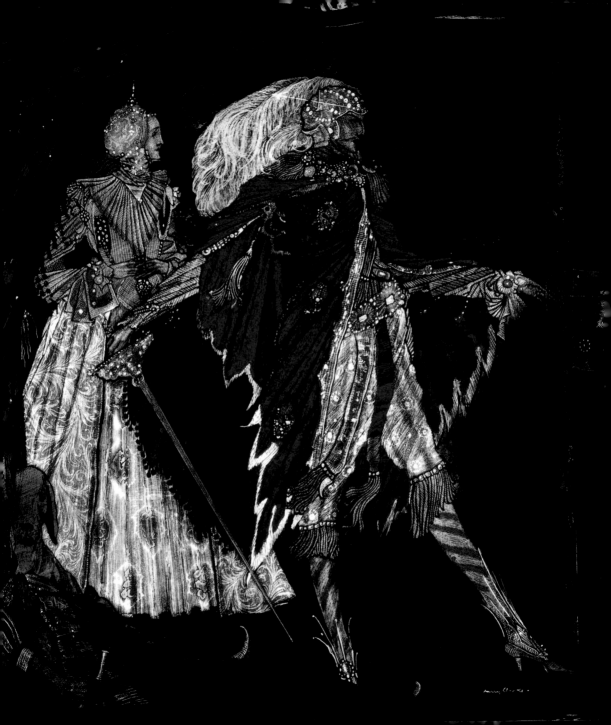

HARRY CLARKE
(1889–1931)

The Eve of St Agnes, 1924, detail

Stained glass, 157.5 x 105 cm (whole window)
Signed and dated: Harry Clarke, April 1st 1924
Purchased, 1978
Reg. 1442

HARRY CLARKE'S GENIUS WAS HIS ability to marry a fantastical imagination to technical ingenuity. Born in Dublin in 1889, he studied at the Metropolitan School of Art, followed by travels to London and France, where he studied medieval stained glass and came in contact with Symbolism and the avant garde. As well as being a stained glass artist, Clarke was a book illustrator of international renown. His illustrations accompanied many celebrated books, including *Tales of Mystery and Imagination* by Edgar Allan Poe. Eerie, sensual characters inhabit turbulent landscapes and dark medieval interiors, creating a wonderful mixture of gothic mystery and romance. As well as being influenced by modernism, Clarke was also inspired by the intricate designs found in ancient Celtic art, which he adopted in his own work, making it unique amongst his peers.

The Eve of Saint Agnes is one of Clarke's finest secular works, and was commissioned by Harold Jacob in Dublin. An admirer of John Keats's poetry, Clarke selected this poem as the theme for the window. Exotically dressed guests emerge out of a 'bitter chill' to party in the draughty, but extravagantly decorated medieval castle, as was the tradition on the Eve of Saint Agnes. It is also tradition that the maiden of the house (in this case Madeline) retires early to dream of her future beau. In Keats's poem Madeline is lured from the castle by her lover, Porphyro. Sneaking past the drunken guard, the lovers step out into the night, fleeing to 'the southern moors'. Clarke's profusion of motifs of marine life, as well as flora and fauna, add to the extravagance and fantasy of the scenes.

JACK B. YEATS
(1871–1957)

The Ball Alley, *c.*1927

Oil on canvas, 45.7 x 61 cm
Signed, lower right: Jack B Yeats
Donated by the Friends of the National Collections of Ireland, 1973
Reg. 1337

'THERE IS ONLY ONE ART and that is the art of living. Painting is an occupation that's in that art, and that occupation is the freest of all the occupations of living.' Jack Butler Yeats was the only one of his family to follow in his father's footsteps as a painter. In his youth he lived for several years with his grandparents, the Pollexfens in Co. Sligo. He drew on the magnificent scenery and the traditional lifestyle of the people as inspiration for his art. Horse racing, fairs, the circus, boxing and other popular sports all fed into his subject matter. A nationalist supporter, Yeats also captured key events in the birth of modern Ireland, and his work reveals his acute observations on the human condition.

As his work developed he began to experiment with technique and colour. His paintings became more expressionist and dramatic, adopting bold colours applied in thick paint with strong gestural brushstrokes. One of the great European expressionist painters of the twentieth century, Yeats's oeuvre shows strong parallels with the work of Lovis Corinth and Oscar Kokoschka.

Handball was very popular in Ireland in the first half of the twentieth century, and the ball alley, a four-walled court similar to a squash court, was a feature in towns and villages throughout the country. In *The Ball Alley* the emphasis is on the blonde player on the left. With his set jaw and taut muscular frame, he personifies determination and grit. The figures flanking the players are brutally truncated, and all emphasis is on the game. The tension is heightened by the attention Yeats gives to the alley, a beautifully abstracted space that looms over them.

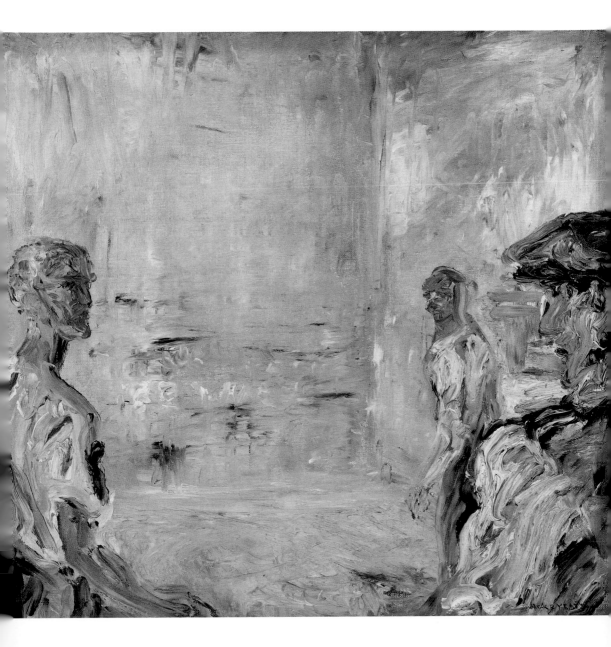

FRANCIS BACON
(1909–1992)

'Seated Figure and Carpet', c.1966

Oil on canvas, 198 x 147 cm

Purchased from the Estate of Francis Bacon with donations to the Hugh Lane Gallery Trust 2005 from Tedcastles
Oil and the Conlan Family through Section 1003 of the Taxes Consolidation Act, 1997

Reg. 1973

FRANCIS BACON'S RADICAL REALITY IS BORN OUT OF his visceral responses to his milieu and the tumultuous events of the twentieth century. His subjects are anti-heroes, both fearsome and tender, who, in their distortion, retain some of their characteristics, creating a fine tension between image and representation, unsupported by any narrative. These compelling images, as he put it, 'unlock the valves of feeling and therefore return the onlooker to life more violently'.

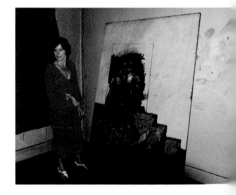

In 1997, following discussions with Brian Clarke, the Executor of the Bacon Estate, regarding a Bacon exhibition, I was invited to Bacon's studio, where I met John Edwards, the artist's heir. Nothing could have prepared me for the experience of stepping into that space. The violence of the chaos, the riot of colours on the walls and the lingering smell of turpentine and paint – all were indicative of intense, fevered activity. In this space, some of the greatest figurative paintings of the late twentieth century were created. Our subsequent discussions culminated in the studio and its contents of 7,333 items being donated to the Hugh Lane Gallery. As project director, I managed the challenging task of relocating the studio and its contents to Dublin, as well as the cataloguing of every item. The studio opened to the public in 2001, and remains one of the most significant and acclaimed cultural attractions in Ireland.

Barbara Dawson with '*Seated Figure and Carpet*', discovered during the removal of Francis Bacon's studio in 1998.

During the removal of the studio contents, we discovered '*Seated Figure and Carpet*' (c.1966), which features George Dyer, the artist's lover. The black rectangle partially completed behind Dyer's head is a format Bacon frequently favoured, as he felt it nailed his subjects to the surface of the painting.

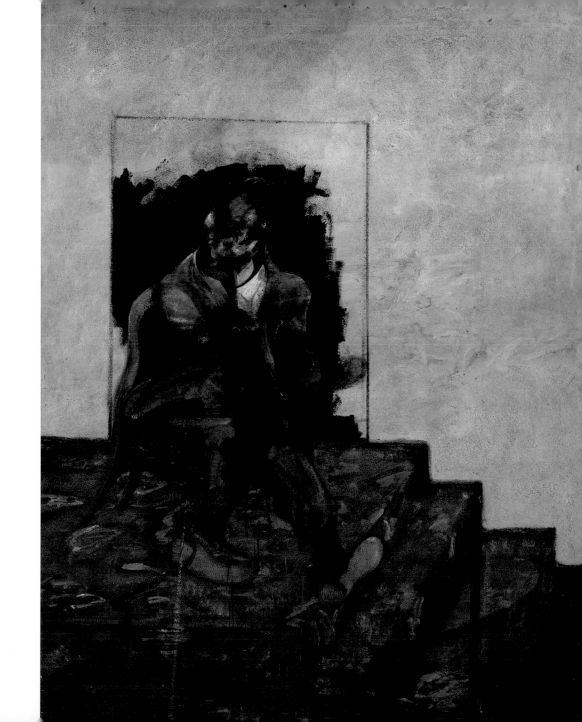

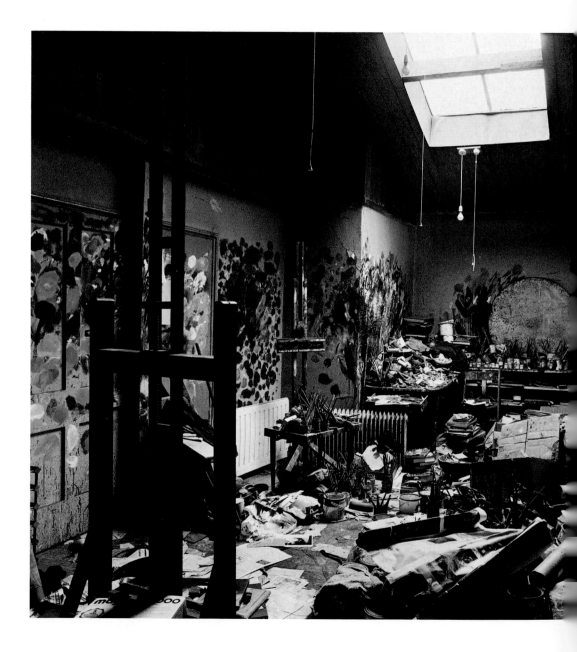

PERRY OGDEN
(b.1961)

Photograph of Francis Bacon's Studio, 1998

C-type print on aluminium, 122 x 152.5 x 5 cm
Purchased, 2001
Reg. 1963.14

'I FEEL AT HOME HERE IN THIS CHAOS because chaos suggests images to me.' Originally situated in 7 Reece Mews, London, this chaotic studio space measuring 24 square metres was Bacon's studio for three decades of his life.

Francis Bacon was born in Dublin in 1909 and raised in Co. Kildare until the age of 16. His studio is a startling and intimate insight into his life and art practice. Photographs of friends and lovers, images torn from magazines and newspapers, letters and notes to himself, books and clothes all jostle together in this famous room. Subjects vary from nature to violent crime, wildlife to sports, history to philosophy, the visual arts to cooking, and all are fed into Bacon's ferocious and passionate realism. It remains a fascinating and quite beautiful space. The walls served as a huge palette, and are covered in hues of pink, blue, red and saffron. Overhead the ceiling, which is covered in spatters from the paint he shook off his loaded brushes, supports a north-facing skylight that provided the cool morning light preferred by the artist. Bacon moved into this studio in 1961 and, although he did purchase other studios, he remained working in this space for the rest of his life. He relished this intense environment, richly layered with the chaos of a tumultuous and successful career, the contents of which slowly disintegrated in step with his advancing years. Perry Ogden was commissioned by the Hugh Lane Gallery to take this final series of photographs of the studio before we transported it from London to Dublin.

LOUIS LE BROCQUY
(1916–2012)

Child in a Yard, 1953

Oil on canvas, 132.1 x 96.5 cm
Signed and dated, lower left: le Brocquy '53
Donated by Mr and Mrs Bomford, 1967
Reg. 1263

LOUIS LE BROCQUY'S OEUVRE is a unique and unswerving enquiry into the human condition and its sentient quiddity. From the outset his work displays an impressive originality that simultaneously reveals his inspirations, including Velázquez and Goya, as well as his study and appreciation of the modern French painters, in particular Manet and Degas. Their reinterpretation of the classical

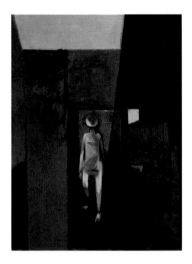

format combined with a pitiless observation of contemporary life saw them become pioneering figures in modern art, a canon to which le Brocquy would later significantly contribute. Tapping into the human presence, his singular imagery hovering between the modern and the primitive earned him national and international critical acclaim, and he became a revered and beloved figure in contemporary Irish art.

Acutely aware of the importance of international discourse and the sense of isolation experienced in Ireland during the Second World War, le Brocquy founded the Irish Exhibition of Living Art in 1943, supported by his contemporaries, including Mainie Jellett and Evie Hone. They brought acclaimed exhibitions of international art to Dublin, generating an ongoing informed discourse on current thinking and practice in visual art.

In *Child in a Yard*, the prevailing mood is one of melancholy. An enigmatic, Cubist-style space of flattened perspective is wrought in cool tones of grey, black-green and white. The young boy emerges out of this austere urban environment. As he stares directly ahead, his naked vulnerability embodies the sense of despair and entrapment of post-war society.

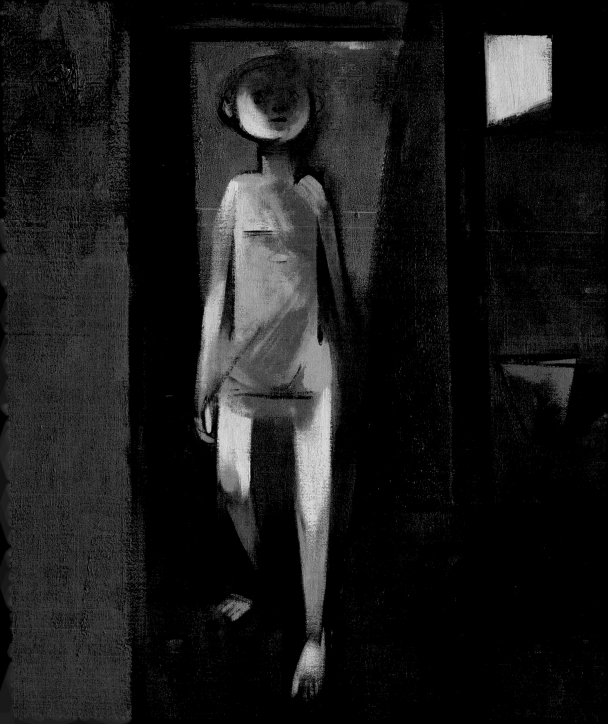

PATRICK SCOTT
(1921–2004)

Large Solar Device, 1964

Tempera on canvas, 234 x 153 cm
Donated by the Contemporary Irish Art Society, 1964
Reg. 1233

LARGE SOLAR DEVICE IS PART OF THE SUITE OF WORKS known as *Device Paintings* created between 1962 and 1964, which are hugely significant in the career of Patrick Scott. The *Device Paintings* were born out of the artist's dismay and anger over testings of the H-bomb (known colloquially as a 'device') in the 1950s. The cold orange ball exploding is the spectacle which is created moments after an H-bomb explosion. Scott's sphere explodes onto the flat surface of unprimed canvas. Being unprimed, the canvas facilitates the colour bleeding from the burning disc over the horizon line created by the vertical format of the diptych and down to the edge of the work and beyond. The paler areas of colour at the edges of the disc suggest an eventual draining away of its mighty energy, resulting in nothingness, both beautiful and diabolical.

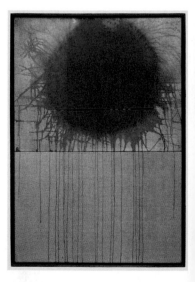

Speaking of the *Device Paintings*, Scott recalled, 'I painted them in sort of anger. They were all very explosive kind of paintings.' Looking at them now, the inherent passion underlying their creation continues to pulsate, and reminds us that the perceived calm of Scott's work is wrought from fervent responses to the world around him, and thoughtful, informed concern for mankind and its environs. *Large Solar Device*, though chilling in its message, is an inherently beautiful painting. Monumental and passionate, it does not evade the beauty that is the natural world, albeit manipulated for potential disaster by mankind.

The monumental scale, insistent flat surfaces and treatment of image in *Large Solar Device* place Scott firmly in the tradition of modernist painting, to which he has made a significant contribution.

ANNE MADDEN
(b.1932)

Waves, 2016

Oil on linen, 145 × 267 cm
Donated by the artist, 2018
Reg. 2069

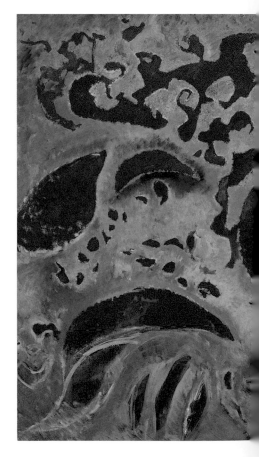

ANNE MADDEN'S ABSTRACTED LANDSCAPES are imaginative and emotional responses to place and memory. They are imbued with symbolic potency that dwells on the complexities of the natural order and the tragedy of existence. Madden combines classical culture with contemporary aesthetic in works that have a mnemonic effect, linking us to the heritages of long ago. As a poetic artist, symbols, images and myths feed into her creativity, and her quest for a deeper understanding of the natural world is central to her concerns. She is also influenced by Eastern mysticism and the concept of the inseparability of space and time, which, as she says, is a continual dynamic present.

Waves is a triptych from her exhibition *Colours of the Wind – Ariadne's Thread*, which I curated in 2017. It is inspired by the story of Ariadne, the Greek goddess whose golden thread saved Theseus's life after he slayed the Cretan minotaur. For Madden, myth opens to notional places, and in *Waves*, Ariadne weaves her way through celestial spaces, her golden thread curling about her. Order and chaos rub up against each other, igniting the surface with spectacular, chromatic effects, which light up like cosmic rays.

The Greeks used the word 'cosmos' to describe a world of perfect order and harmony. Today, the cosmos embraces the total sum of everything, an infinity of solar systems and galaxies that challenge comprehension. Madden continually seeks to understand the

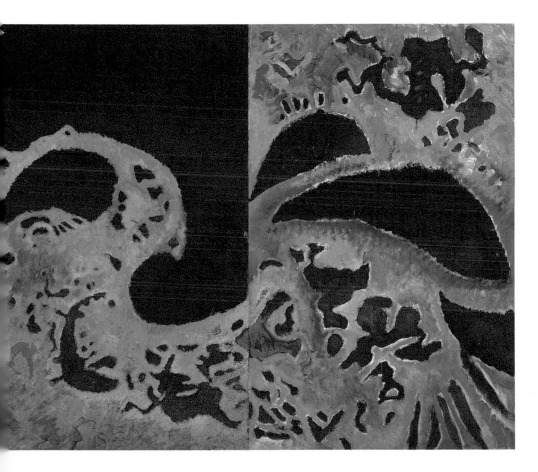

natural order and, through her art, attempts to uncover realities
that exist but are unseen.

AGNES MARTIN
(1912–2004)

Untitled No. 7, 1980

Gesso, acrylic and graphite on canvas, 184 x 184 cm

Signed, on verso, A. Martin 1980

Purchased, 1980

Reg. 1446

THIS PAINTING WAS FIRST EXHIBITED at the 1980 ROSC exhibition in Dublin. ROSC was a series of international temporary exhibitions, organised in Dublin approximately every four years between 1967 and 1988. One of the most important events on the global art calendar, ROSC provided Irish audiences with wide-ranging exposure to international art practice in a way that has never since been repeated in Dublin. The Hugh Lane Gallery hosted the event in 1977.

Canadian artist Agnes Martin is one of the great exponents of Abstract Expressionism. From the late 1950s to the late 1960s she lived in Manhattan, where she shared a studio space in the Coenties Slip with other artists, including Ellswoth Kelly. She returned permanently to New Mexico in 1968, to the white light and rose-coloured deserts that permeate her work. *Untitled No. 7* is solely about visual perception, with a complete absence of representational or literary references. In a lecture Martin gave at Yale University in 1976, she said, 'The artist tries to live in a way that will make a greater awareness of the sublimity of reality possible.'

Acquiring *Untitled No. 7* caused uproar in Dublin. With its horizontal bands of delicate blues, whites and pinks, it is extremely difficult to reproduce, hence it became known as the blank canvas. One newspaper declared, 'Corporation votes to pay £20,000 for blank canvas'. Despite the controversy, Dublin Corporation did purchase the work for the gallery, and since then Agnes Martin's stature as an artist has soared, as too has the value of this sublime work.

SEAN SCULLY
(b.1945)

Landline Gray, 2015

Oil on aluminium, 215.9 × 190.5 cm

Signed, on verso: LANDLINE GRAY Sean Scully 2015

Donated by the artist, 2018

Reg. 2070

SEAN SCULLY IS ONE OF THE MOST RENOWNED living abstract painters. His visceral responses to the world around him are found in his pigmented stripes, rectangles and squares, a corpus of astonishing range and diversity. Dense and light-filled, structured and passionate, wayward and disciplined, Scully's compositions are a taut balance of competing elements which come together in sublime and poetic works of art.

Scully's *Landline* series reveals his recent looser, more expressive style, and is influenced by recent visits to Venice, where the city's famous luminous light plays on the waters of the Adriatic lapping up against the ancient stonework. *Landline Gray* is built up in broad bands of blue, black and grey. The fluid, choppy brushstrokes, walloped onto the huge aluminium surface, envelop the viewer in the rhythmic movements of the sea and sky, evoking the Earth's monumental beauty as well as its implacable nature.

Landline Gray's vast expanse of grey sky which stretches over the cold blue sea and dark earth is reminiscent of the magnificent bleakness of the West of Ireland, where looking out to sea on the most western landmass of Europe, below the low horizon line, the lineaments of previous existences can be discerned in the scored landscape as well as pictured in the heft and swell of the vast Atlantic Ocean. These primordial life forces reappear in the beat of the artist's gestural brushstrokes across the surface of this painting. As Scully observes, 'Life is not a straight line … everything is continuously gathered up and remade in the folding rhythms of its song.' Or, to quote James Joyce, 'There is not past, no future; everything flows in an eternal present.'

PHILIP GUSTON
(1913–1980)

Outskirts, 1969

Signed: Philip Guston

Donated by the Conlan Family through Section 1003 of the Taxes Consolidation Act, 2005

Reg. 1985

WHEN STILL A YOUNG BOY, Philip Guston moved with his family from Montreal to Los Angeles, where he became involved in left-wing activism. During the 1920s and 1930s, the Ku Klux Klan was very active. In 1931, Guston and fellow artists created a series of murals known as the Scottsboro panels in protest at the violent treatment of Black citizens. Guston's mural of a Black man being whipped by the Klan was destroyed by the Red Squad, who were part of the LA police force.

By the 1950s, Guston had established a very successful career as an Abstract Expressionist. However he grew restless with the restrictions and limitations of abstract painting, having developed a desire to create a world of images, subjects and stories.

Outskirts was acquired for the collection in 2005. It is a fabulous example of Guston's later work, and was part of his famous exhibition of 'hoods' at the Marlborough Gallery, New York, in 1970. His cartoon-like depictions of the KKK show them ominously encircling a citadel. The idea of evil fascinated Guston, and he started to conceive of a city overtaken by the Klan. This exhibition publicly signalled Guston's return to figurative painting and caused a huge furore. 'It was as though I had left the Church; I was excommunicated for a while'.

Guston enjoyed some of the most scathing titles ever given by art critics to an art exhibition. Hilton Kramer in the *New York Times* declared his 1970 exhibition to be 'A Mandarin pretending to be a Stumblebum', and Robert Hughes (who later reversed his opinion) called it 'Ku Klux Komix'. Guston prevailed, however, and his works continue to grow in international stature and acclaim.

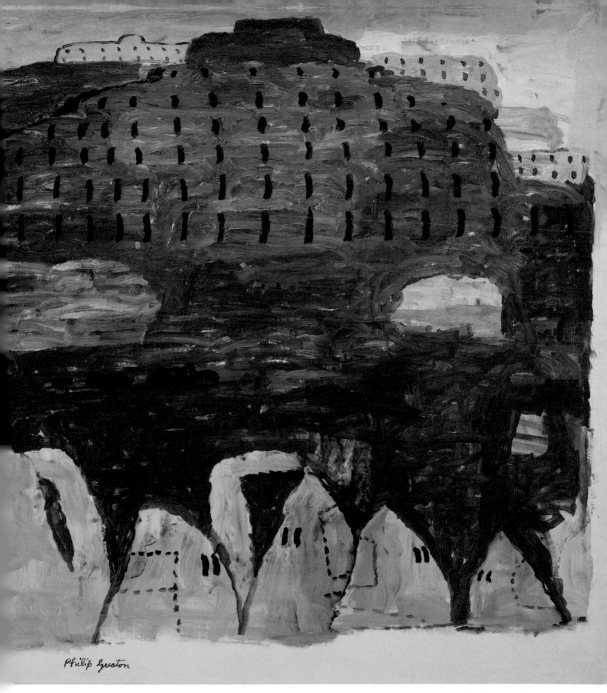

BARRY FLANAGAN
(1941–2009)

Horse (Mirrored) (Cow Girls: Sheep Boys), 1995

Bronze, 146.7 x 106.7 x 40.6 cm / 154.9 x 106.7 x 40.6 cm
Donated by the artist, 1996
Reg. 1891

BARRY FLANAGAN WAS ONE of the most original British sculptors to emerge in the 1960s. He was part of London's countercultural movement and sought to forge new expressions with traditional materials. His enquiry into new research and being open to chance and a certain autonomy in the creative process all contributed to his ongoing exploration of structure, space and movement.

Influenced by the ideas of French dramatist Alfred Jarry, who invented 'Pataphysics, the science of imaginary solutions, Flanagan's multimedia oeuvre is composed of a radical corpus of inventive, curious and transformative work. Quixotic and paradoxical collaboration was critical to Flanagan's solutions. Reflecting on the roles of artist and artisan, and the skills employed by craftsmen in creating his work, Flanagan explains 'they are my musicians and I am the composer'.

Barry Flanagan with *Horse (Mirrored) (Cow Girls: Sheep Boys)*, in the Hugh Lane Gallery, 1996.

The mythical qualities associated with the hare inspired Flanagan's anthromorphic bronze sculptures, as featured in 'Barry Flanagan on O'Connell Street', organised by the Gallery in 2006. Other animals also feature in his oeuvre, notably the horse. He was much influenced by the ancient bronze horses from San Marco's Basilica in Venice, which he saw on exhibition in London in 1979. These massive antique sculptures exude an aura of nobility and power, embodying the imperial might of their creators.

Flanagan's *Horse (Mirrored)* are male and female parallel images, apart from a top knot and flowing mane on the head of one. The splendour of these magnificent creatures is invested in both the male and the female, prompting us to think again about cultural imagery and signifiers.

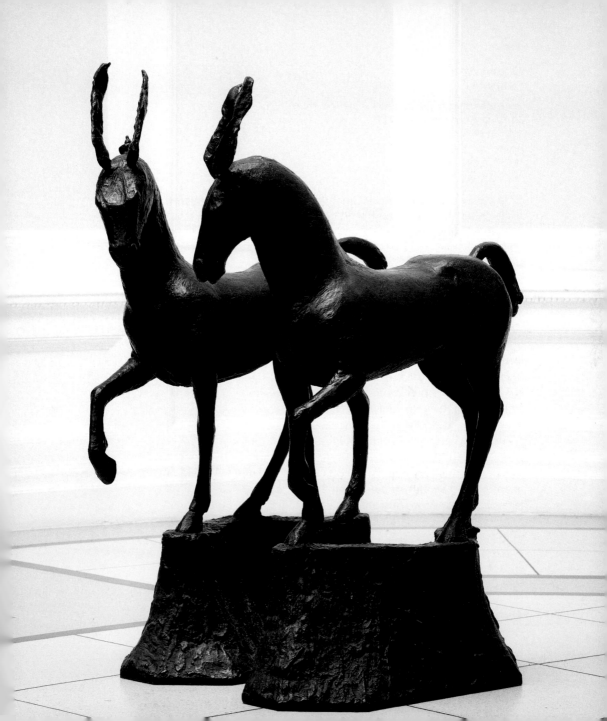

MICHEAL FARRELL
(1940–2000)

Madonna Irlanda or The Very First Real Irish Political Picture, 1977

Acrylic on canvas, 174 x 185.5 cm

Purchased, 1977

Reg. 1436

IN THE 1960S, FARRELL ESTABLISHED HIMSELF as one of the leading Irish artists of his generation with his hard-edged abstract compositions. He never entirely embraced the objective minimalism of his US peers, however, introducing into his work curvilinear and rectilinear forms, echoes of early Celtic motifs. The end of the 1960s saw him review his aesthetic approach, moving towards a 'more human and personal style', where he could make literary connotations, incorporating allegory and irony into his work.

Farrell's *Madonna Irlanda* series is a fiercely polemic sociopolitical commentary on Ireland. Created during the height of the Troubles in Northern Ireland and based on François Boucher's painting *Resting Girl* (which used as a model Marie-Louise O'Morphy, the Irish courtesan of Louis XV), this series 'makes every possible statement on the Irish situation, religious, political, the cruelty, the horror, every aspect of it'.

There is a suggestive blasphemous play on 'Madonna' (Our Lady and Mother of God) and Mother Ireland. Farrell's Ireland has become politically submissive, akin to the murky world of prostitution. The broken nimbus on the young girl's head suggests all honourable behaviour has been jettisoned, and the image of Leonardo's *Vitruvian Man* celebrating the proportional relationship and balance between man and nature is likewise collapsed. The play on Boucher (butcher) sees others in this series label Miss O'Morphy's anatomy as in illustrations of butcher's cuts: the forequarters, the gigot and knee cap, the latter directly referencing the practice of kneecapping in Northern Ireland. A fiercely critical émigré living in France, Farrell peers down on the political mayhem.

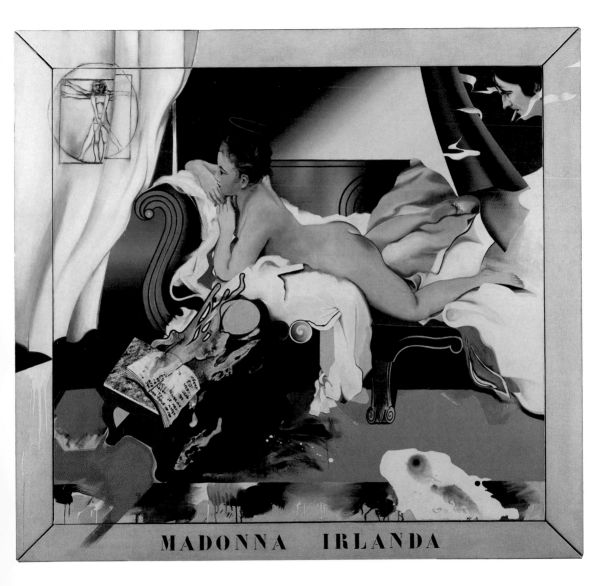

BRIAN MAGUIRE
(b.1951)

Jail Visiting, 1990

Multimedia on canvas, 203 x 203 cm

Purchased with donations given to the Hugh Lane Gallery Trust, 2005

Reg. 1978

BRIAN MAGUIRE'S WORK GIVES VISIBILITY and form to communities and situations in society that are hidden and unseen. He is an activist for those on the margins of society, and his commitment to psychological authenticity in his aesthetic responses underpins his practice. The strong gestural brushwork and vibrant palette create narratives that are controversial as well as compelling and thought-provoking. Although his subject matter is difficult, Maguire admits he aims to make a thing of beauty, because 'beauty is what lures the viewer in'.

In the mid-1980s Brain Maguire began teaching in Portlaoise Prison in the Midlands of Ireland. The project was organised by the National College of Art and Design with the Department of Justice. Maguire's policy was to engage through demonstration rather than through lecture, and this openness to discourse with the prisoners was highly successful, leading to some of his students successfully pursing an artistic career after serving their sentences. *Jail Visiting* resulted from his experiences of an overcrowded jail in Cork. He was shocked at the conditions in the visiting area (depicted in the lower part of the painting), which he said was 'like a bookies office on Grand National Day'. The horizontal figures locked in an intimate embrace cut across the centre of the composition. The beauty of the bodies, built up in warm fleshy tones, are in stark contrast to the dark and dirty backdrop, and are far removed from the scene below. For a brief period they become lovers and individuals. The conjugal visit is Maguire's fantasy, as such visits are rarely if ever allowed in prisons.

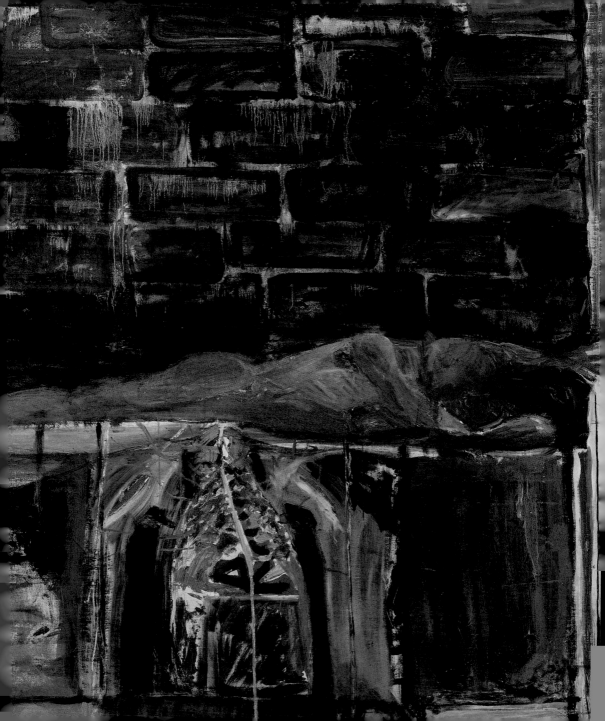

WILLIE DOHERTY
(b.1959)

At the Border II – (Low Visibility), 1995

Cibachrome on aluminium, 122 x 183 cm

Purchased, 1996

Reg. 1898

WILLIE DOHERTY IS A PIONEERING FIGURE in art, film and photography. His work emerges as a complex reflection on how sociopolitical turmoil has shaped and affected places, suggesting secret histories and mysteries. His images fully acknowledge the ambiguities, complexities and paradoxes that bring them into being.

Willie Doherty's work begins as a response to terrain, and has its roots in the politics and topography of his native Derry. He witnessed Bloody Sunday at the age of 12, and although in recent times his work has responded to other locations, Derry and its environs remain a primary point of reference. The walls of Derry, the River Foyle dividing the city between east bank and west bank, and the proximity of the border with the Republic of Ireland creates, as he says, 'a perfect theatre of war'. Focusing on this territory of conflict and military surveillance, where an objective perspective is impossible, Doherty sets up contradictory points of view, often layering image with text loaded with alternative interpretation, such as 'Protection/Surveillance', revealing the prejudices and assumptions that such words carry.

In *At the Border II – (Low Visibility)*, Doherty is silently observing movements at the Northern Ireland border by night. The gravel road reveals a huge tyre mark typical of a military vehicle, suggesting recent activity, while in the distance the oncoming headlights of a car glow in the dark. Suspense mounts as we survey the scene. Lit from the foreground and viewed from a downward perspective, this ambiguous scene is enfolded in a dense black landscape. Borders define identity as well as political and legal jurisdiction. Here Doherty explores issues of territory and division on a conflicted border, leaving us the viewer to interpret the event according to our standpoint and prejudices.

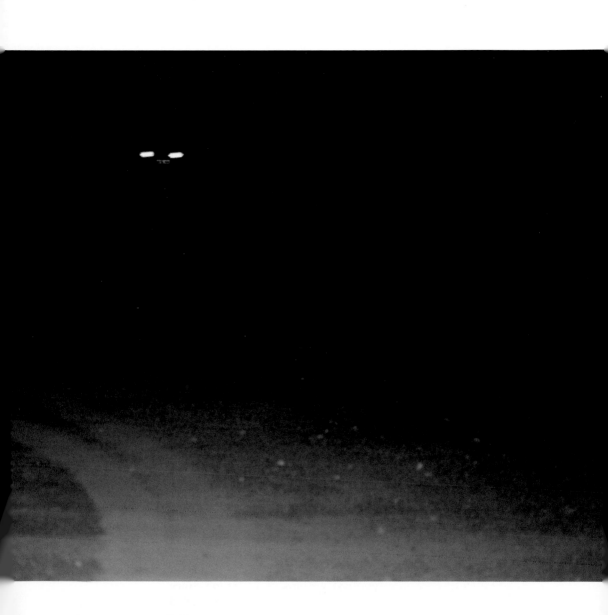

Elizabeth Magill
(b.1959)

Grayscale (2), 2005

Oil on canvas, 137 x 168 cm
Purchased, 2006
Reg. 1998

ALTHOUGH ELIZABETH MAGILL DOESN'T necessarily refer to herself as
a landscape painter, there is a lifelong commitment to the landscape
in her work. In the canon of European art great landscape painting
is driven by an informed or intellectual desire to make visible the
universal essence of things, rather than that which merely consists
of mechanical copying of particular appearances. Or, to paraphrase
Magill, the spaces she creates in her landscapes are metaphors for
contemplation of the bigger picture and what it means to be part of
this world. Informed by the majesty of the landscape of her native
Co. Antrim, one of the most beautiful parts of Ireland, her land-
scapes are biographical and a front behind which life's struggles and
challenges are played out.

A surreal, somewhat perplexing atmosphere pervades *Grayscale (2)*,
augmented by a certain filmic quality that is a characteristic of
Magill's work. She creates strange worlds from familiar terrain
– trees, mountains, grasses and skies – which are transformed
into thoughtful, contemplative spaces. Magill works in sequenced
stages, often beginning with thin washes of oil followed by detailed
layers of deft brushwork, creating the recognisable elements in
her compositions.

Magill's 'liberal idea of nature' is created from the inventive
manner in which she manipulates her materials, most especially
her paint. She pours the paint onto a taut stretched canvas, waiting
to see what emerges from the saturation, abstracted shapes that she
will grasp and conjure into solid forms – hybrid images, exciting,
intriguing and dramatic. A new reality, making room for complex
discourses on the nature of existence, emerges from the chaos.

YINKA SHONIBARE
(b.1962)

Climate Shit Drawing 6, 2009

Ink, Dutch wax cotton printed textile, newsprint and gold foil on paper,
113 x 237.5 cm
Purchased, 2016
Reg. 2059

YINKA SHONIBARE IS A painter, photographer, filmmaker and installation artist who draws on the cultures of both his native Nigeria, where he was educated, and England, where he subsequently studied and now lives. His work focuses on the legacies of nineteenth-century European colonisation and its power structures, which are found in the conflicting ideologies and politics in post-colonial societies, as well as the effects of globalisation on the planet.

In 2009, the Hugh Lane Gallery commissioned Yinka Shonibare to create a sculptural tableau installation as part of its temporary exhibition programme. Based on an episode in Jonathan Swift's *Gulliver's Travels*, when the Lilliputians and the Blefuscudians fight over which end of the egg should be broken first, *Egg Fight* features two headless mannequins, eighteenth-century dandies dressed in flamboyant bespoke Dutch wax cotton attire, shooting at each other through a net of eggs.

Shonibare's adaptation of Swift's satire on the ongoing wars between Catholics and Protestants in eighteenth-century Europe results in a humourous and thought-provoking dialogue on hierarchy and dominance, and its effects on the hybrid cultures found in post-colonial society.

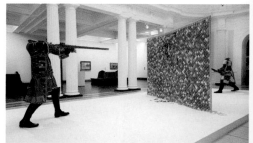

Egg Fight (2009), at the
Hugh Lane Gallery.

As part of the exhibition Shonibare also created a series of
Climate Shit Drawings, which address the effects of the global eco-
nomy on the planet. *Climate Shit Drawing 6* comprises printed
Dutch wax cotton, newsprint, gold foil, hand-drawn images and
texts from newspapers. Automatic drawing, images of flora and
fauna created from pages of the *Financial Times*, texts on rising oil
prices and newspaper headlines come together in this kaleidoscopic
composition, displaying a clash of competing interests – economics,
aesthetics and the beauty of the natural world.

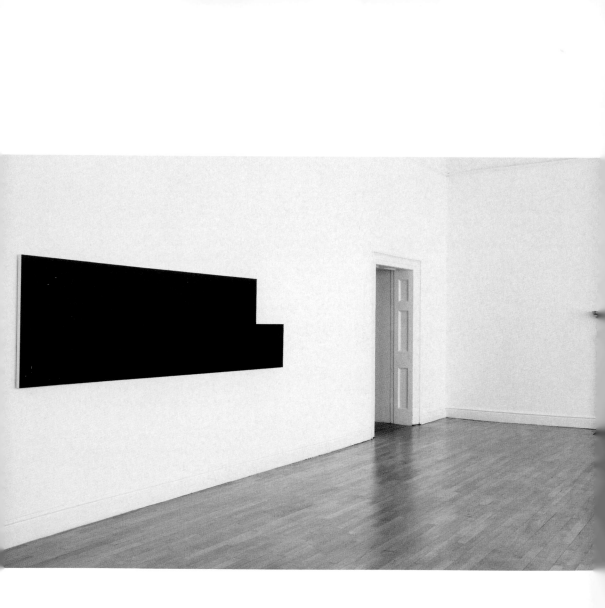

FERGUS MARTIN
(b.1955)

Rose, 2008
Acrylic on canvas, 82 x 263 cm
Purchased, 2010
Reg. 2024

THE WORK OF FERGUS MARTIN, painter, printmaker, sculptor and photographer, is not representational – rather it represents an extension of the real world, with all the problems and solutions inherent in existence. Inconsequential and fleeting images – the glow of a motor car's headlights, the rising tide of a river, the magnificence of the patina on an old wooden chair – all feed into a thoughtful and rigorous oeuvre which pulsates with a quiet confident energy, fully aware that it is making a vital contribution to the realm of sensory experience.

Rose consists of a mass of colour that stretches out over the entire frame, but is thwarted in its attempts to completely fill its space by a disruptive square of white. High drama and excitement are condensed into planes of unbroken colour. Light boomerangs off the painting's smooth skin only to bounce back into the depths of the work, heightening the phenomenological experience.

Packed with his acute responses to the physical world, Martin's paintings are elevated distillations of impassioned expression which readily divulge their subtle sensibilities to the engaged viewer. Their intrinsic sensuousness is not readily apparent; it sneaks up on you through the beautifully textured flat surfaces layered with his rich monochrome colours. As he explains, 'Rose is a pink brown – sunburnt skin'. Like a river at high tide, Martin's paintings push themselves to the edge, only to be held fast by the compositional boundary and 'occasional bites of white'.

Rose was part of Fergus Martin's solo exhibition at the Hugh Lane Gallery in 2008.

DOROTHY CROSS
(b.1956)

Shark Lady in a Balldress, 1988

Bronze, 110 x 70 x 70 cm
Purchased, 1992
Reg. 1825

DOROTHY CROSS'S PRACTICE IS BORNE out of a visceral response to the natural world, informed by an astute and adroit enquiry into the human psyche. She works with a diverse range of materials, including wood, steel, silver, found objects, music, film and photography, challenging conventions and the accepted norm, forcing us into a new way of seeing.

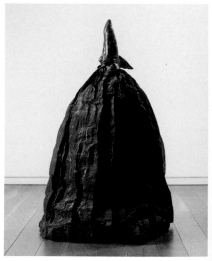

The shark's relationship with mankind conjures up visions of aggression, fear and death, and has captured the imagination of poets and writers for centuries. The shark is a recurrent theme in Cross's work, revealing her long-held fascination and respect for this much maligned fish. As she points out, it is one of the oldest living creatures, believed to be over 200 million years in existence, as compared to *Homo sapiens* (200,000 years old). Her deep knowledge of the sea, informed by her living in the west of Ireland, ocean travels and scuba diving, has led to the shark playing a significant part in her renowned oeuvre. Witty but disquieting, *Shark Lady in a Balldress* confounds any traditional reading of the shark, and indeed the ballgown, as the phallus shoots out of the voluminous skirts bearing fins and breasts. Clad in Victorian attire associated with demure, ladylike reserve, she confounds convention – an empowered erotic female boldly confronting her viewers. In this challenging, amusing sculpture, Cross explodes traditional norms of male dominance and power versus female docility and reserve, as well as the usual assumption that all sharks are male. Contentious, it is also endearing, underpinned by an elemental beauty and vulnerability.

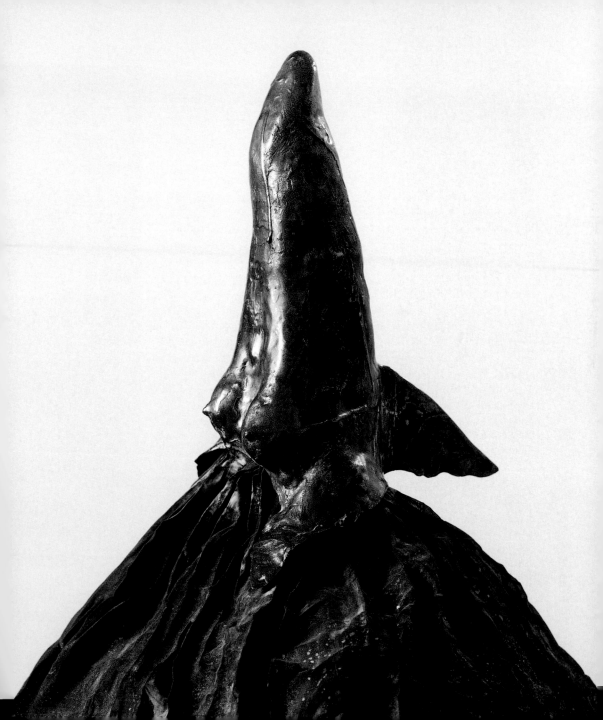

JAKI IRVINE
(b.1966)

Ivana's Answers, 2001

DVD, single-screen projection, 10.50 mins
Purchased with donations given to the Hugh Lane Gallery Trust, 2005
Reg. 1976

ONE THING YOU CAN BE SURE OF when watching this dreamlike single-screen film is that answers are very slow in forthcoming. It is a beautiful film in the way that poetry is beautiful, a looped cycle of images and words woven together in an elusive, enigmatic narrative. It is centred around two women: one reading tea leaves to tell the other's fortune. Surreal in its treatment, the film begins with a train moving out of the station at night-time like the opening scene in a thriller. A man walks across the railway track; two hands clasp around a lamp-post; and a woman walks away, while the train vanishes into the night. Abruptly, the rhythm shifts to a close-up of a fragment difficult to decipher, but which we discover is a vast collection of insects on the table: flies, beetles and scorpions in vivid greens and ultramarine. One woman begins to read the tea leaves in the other's cup. The close-up of the tea leaves echoes the shape of the insects. As they speak we find the narrative to be equally elusive and ambigious.

'The train is not there … and he hasn't arrived.'

'What do you mean?'

The broken and inconclusive narrative continues. Towards the end one woman peers through a narrow slit in a cage, where two falcons move about, agitated in their small, confined space.

'They're the answers … answers to your questions.'

'What questions?'

'Exactly.'

Complex and wayward, *Ivana's Answers* subtly unnerves the viewer with its philosophical insights into perceived reality, and by challenging our perceptions of the world around us brings about new ways of seeing.

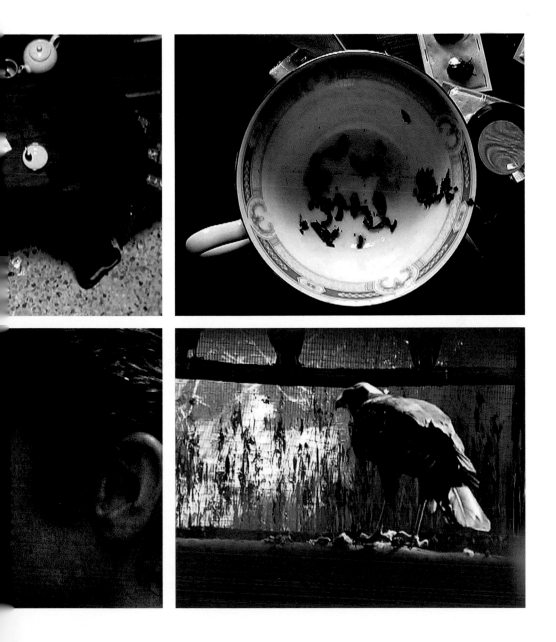

LILIANE TOMASKO
(b.1967)

Lightly Lifting the Hidden Unfold, 2015

Oil on linen, 152.4 x 139.7 cm
Donated by Mr Patrick McKillen, 2016
Reg. 2052

THE INTIMATE DOMESTIC ROUTINES of the everyday are the focus
of Lilian Tomasko's concerns – especially bed, where we go to
relax and sleep, a private time, respite from the quotidian activities
that make up our active world. Here we can disappear into our
unconscious, into our dreams, which plumb our memories, our
experiences, our desires. Private and secluded, it is, however, one of
life's essential activities. In Macbeth the king ruefully acknowledges
that sleep is central to living:

> Balm of hurt minds, great nature's second course,
> Chief nourisher in life's feast.

As Tomasko reflects, 'Sleep and the dream realm are where we
go to even deeper levels of ourselves. It is a kind of journey into our
most intimate space ...' In this painting the seclusion and warmth
associated with sleep is suggested by the sensuous curves and
forms in swathes of vibrant colour and swirling lines that undulate
across the picture plane. Although not representational, they convey
the tactile nature of luxuriant fabrics, folding and unfolding like
bedlinen draped over the sleeping body. Protective and tender, the
vitality of the composition, with its rhythmic movements, conjures
up the surreal, exciting and unfettered world of dreams, making us
reflect on their significance, and influencing on our waking reality.

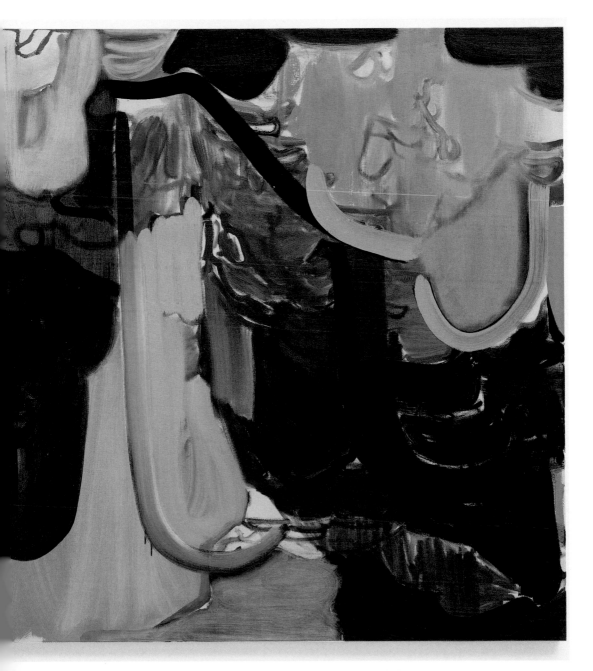

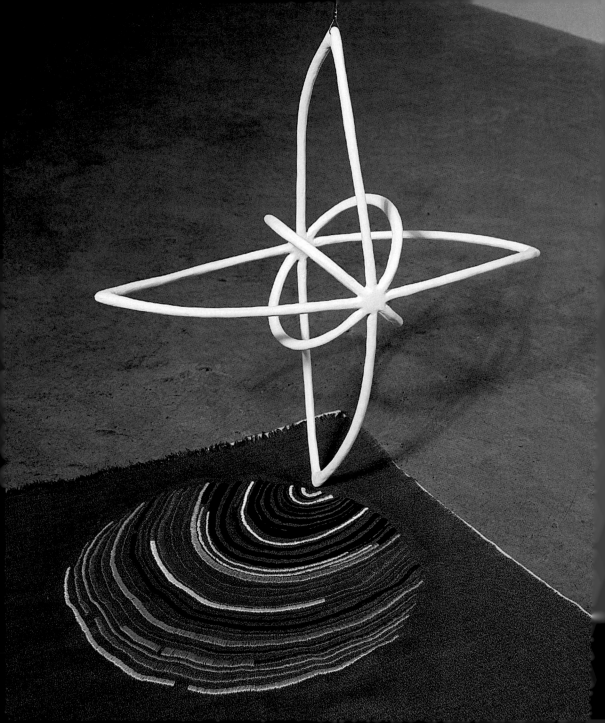

Isabel Nolan
(b.1974)

Rings of Saturn, 2007

Cotton, linen, embroidery silk, thread (textile component), plastic straws, copper rods and wire, fibreglass and paint (3D component), 101 x 117 cm
Donated by Sean Scully, 2007
Reg. 2007

Isabel Nolan's art is the result of intense investigation into our relationship with the complexities of nature. Nothing is off limit: the sciences, the cosmos, botany, as well as literature and history all inform aspects of her intelligent and thought-provoking work, which comprises sculptures, textiles, paintings, photographs and works on

paper. These diverse means underpin her fundamental questioning of our realities and relationships with the myriad complex systems upon which life and our experiences of it are predicated. The precariousness of balance and harmony experienced in her work speaks of the delicate interconnections that hold together the complexities of the natural world, as well as to the unfathomable magnitude of the cosmos. Through her singular artistic sensibility, Nolan's continuous search for greater understanding of the experiential sees her disturb and unsettle even the most familiar forms, illuminating the strangeness and splendour of existence.

Rings of Saturn takes its title from W.G. Sebald's book, which is a remarkable journey through memory and history. Saturn is one of the most fascinating of the planets, having over 30 orbiting rings of varying dimensions. Nolan's installation consists of a sculpture of four white ellipses hovering over a delicately embroidered pattern of rings of diminishing size halted by the point of one of the ellipses.

In this work the inherently intimate artistry of needlework is balanced against the potent workings of the solar system in a reflection on the constructs of the natural world and our mental capabilities to comprehend them.

KATHY PRENDERGAST
(b.1958)

Atlas 6, CORK-DUBLIN (from the *Atlas Series*), 2017

Ink on AA Road Atlas of Europe, 30.5 x 43.5 x 1 cm
Purchased, 2017
Reg. 2062.04

A ROAD MAP DISPLAYS ROUTES and transport links. It does not include geographical information, but it does include political borders, making it a type of political map. Mapping has been central to Kathy Prendergast's work from the beginning. From her *Body Maps* in 1983, which charted and excavated the female form, to her *City Drawings*, delicately wrought maps of the capital cities of the world (for which she was awarded the Premio Duemila at the 1995 Venice Biennale), she has worked on the principle that 'all mapping is subjective'. Prendergast's maps explore issues of territory, boundaries, migration and traces of colonialism.

In *Atlas* Prendergast continues her personal responses to cartography, and the humble A4 Road Map is her material. Using India ink she painstakingly draws over 100 pages of the AA Road Atlas, obliterating all of the map's navigational details apart from the places of habitation, which appear as small white dots in a sea of black. Together these maps make a unique if oblique map of Europe, concerned solely with human occupation. This ruthless redaction, eliminating borders and roads and connecting the places where people live, is a powerfully emotional response to issues of migration, settlement and displacement. Created by erasure and negation, the subject of these maps is nevertheless human presence. Stripped of their original function of assisting navigation of boundaries and political borders, Prendergast's maps focus on collective human engagement, migration and displacement. Enigmatic, non-didactic and often imbued with personal resonances, her work revolves around issues of identity, memory, love, loss and power structures, subtly dismantling prevailing narratives through erasure and transformation.

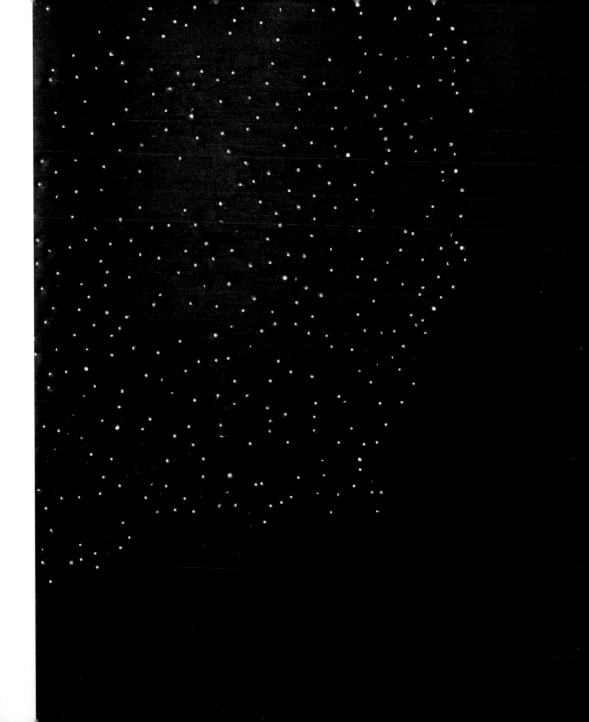

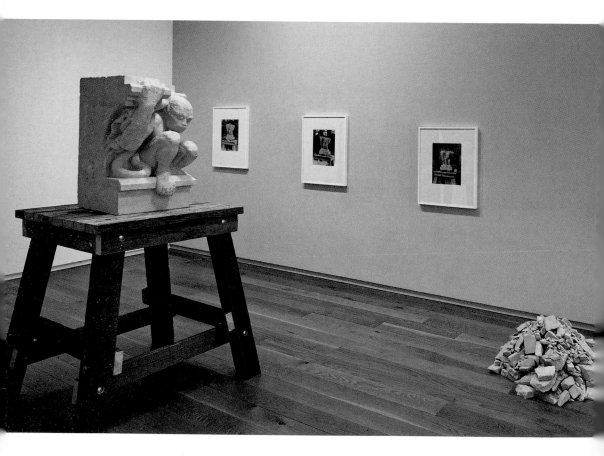

SEAN LYNCH
(b.1978)

A blow by blow account of stonecarving in Oxford, 2013

Stone sculpture on wooden table by Stephen Burke; 35mm slide projection on table with 50 slides, and voiceover
(19 minutes duration); a pile of stone rubble; 6 silver gelatin b/w fibre prints, framed (edition 2 of 3)
Purchased, 2018
Reg. 2072

SEAN LYNCH'S WITTY APPROACH to his work belies his unrelenting investigations into why and how certain narratives become history, while others are relegated to folklore or legend, edited to accommodate one seamless chronological record.

This installation explores the work of John and James O'Shea, the celebrated Irish stone carvers who, with their nephew Edward Whelan, pioneered a free creative style in contrast to the repetitive patterns most commonly employed by Victorian stone carvers. They worked on the Museum Building in Trinity College Dublin, before being commissioned, in 1857, to work on the Oxford University Museum of Natural History.

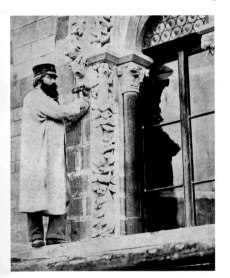

James O'Shea working on the 'cat window' of the Oxford University Museum of Natural History.

Admired by Ruskin, the O'Shea team were given a free hand to carve the images of their choice. However, when they began to carve monkeys, a row erupted. The Oxford dons feared the monkeys would be seen as an endorsement of Darwin's theories on evolution. Annoyed, James O'Shea turned the monkeys into cats based on the ancient image of the king cat of Keshcorran, who, in folklore, guards the caves of hell. As the row escalated, he carved owls and parrots on the façade of the museum – authority's repetitive dictates are made sacrosanct if repeated often enough. The rumour was later propagated that they were fired due to their heavy drinking.

Lynch's installation, with its allegorical and associative meanings, invites contemporary reappraisal of the O'Shea team, and powerfully argues for the recognition of their contribution to the character and identity of the urban infrastructures of Dublin and Oxford.

PICTURE CREDITS

The illustrations in this book have been reproduced courtesy of the following copyright holders:

© The Estate of Francis Bacon. All rights reserved, DACS, London/ IVARO, Dublin 2020, front cover, frontispiece; Image © Manchester City Galleries, UK (Reg. MAN 63015) / Bridgeman Images, p.6; Image © The National Gallery, London. Sir Hugh Lane Bequest, 1917. In partnership with Hugh Lane Gallery, Dublin, pp.7, 11, 13; Photo by Popperfoto/Getty Images, p.12; Image courtesy of the National Library of Ireland, p.16; © Estate of Grace Henry, p.25; © Alan Phelan, IVARO, Dublin 2020, p.31; © Estate of Mary Swanzy, p.33; © Estate of Jack B. Yeats, DACS, London/IVARO, Dublin 2020, p.37; © The Estate of Francis Bacon. All rights reserved, DACS, London/IVARO, Dublin 2020, pp.39, 40; © Estate of Louis le Brocquy, p.43; © Estate of Patrick Scott, IVARO, Dublin 2020, p.45; © Anne Madden, p.47; © Agnes Martin, ARS, New York/ IVARO, Dublin 2020, p.48; © Sean Scully, p.50; © The Estate of Philip Guston, image courtesy Hauser & Wirth, p.53; Photograph by John Kellett, p.54; © The Estate of Barry Flanagan, courtesy Plubronze Ltd, p.55; © Estate of Micheal Farrell, IVARO, Dublin 2020, p.57; © Brian Maguire, DACS, London/IVARO, Dublin 2020, p.59; Image courtesy of the artist and Kerlin Gallery, Dublin © Willie Doherty, p.61; © Elizabeth Magill, DACS, London/IVARO, Dublin 2020, p.62; © Yinka Shonibare, DACS, London/IVARO, Dublin 2020, pp.64, 65; Photograph by Denis Mortell. Artwork © Fergus Martin, p.66; © Dorothy Cross, p.69; © Jaki Irvine, p.71; Image courtesy of the artist and Kerlin Gallery, Dublin © Liliane Tomasko, p.73; Image courtesy of the artist and Kerlin Gallery, Dublin © Isabel Nolan, p.74; Image courtesy of the artist and Kerlin Gallery, Dublin. © Kathy Prendergast, p.77; © Sean Lynch, pp.78, 79.

The publisher and authors have made every effort to trace the copyright holders of the illustrations reproduced in this book; they will be happy to correct in subsequent editions any errors or omissions that are brought to their attention.

Director's Choice is a registered trademark of Scala Arts & Heritage Publishers Ltd.

First published in 2020 by
Scala Arts & Heritage Publishers Ltd
10 Lion Yard
Tremadoc Road
London SW4 7NQ, United Kingdom
www.scalapublishers.com

In association with Hugh Lane Gallery/
Dublin City Council
Charlemont House
Parnell Square North
Dublin D01 F2X9
Ireland
www.hughlane.ie

ISBN 978-1-78551-075-5

Edited by Neil Burkey
Designed by Linda Lundin at Park Studio
Printed and bound in Turkey

10 9 8 7 6 5 4 3 2 1

FRONT COVER:
FRANCIS BACON (1909–1992)
'Seated Figure and Carpet', c.1966
Oil on canvas, 198 x 147 cm
Reg. 1973

FRONTISPIECE:
PERRY OGDEN (b.1961)
Photograph of Francis Bacon Studio, 1998
C-type print on aluminium, 122 x 152.5 x 5 cm
Reg. 1963.21

BACK COVER:
HARRY CLARKE (1889–1931)
The Eve of St Agnes, 1924, detail
Stained glass, 157.5 x 105 cm (overall window)
Reg. 1442